In Print:

In Print:

In Print:

Contemporary Artists at the Vinalhaven Press

Aprile Gallant

David P. Becker

Portland Museum of Art, Maine

This catalogue was published in conjunction
with the exhibition *In Print: Contemporary Artists
at the Vinalhaven Press,* organized by the
Portland Museum of Art, Maine.

Portland Museum of Art, Maine
 April 13 — June 4, 1997

McMullen Museum of Art, Boston College
 June 19 — September 14, 1997

This exhibition is generously sponsored by
KeyBank and L.L.Bean.

Edited by Susan L. Ransom.
Designed by Michael D. Ryus, MDR design.
Color photography by Melville D. McLean.
Printed in Verona, Italy, by EBS.

Distributed by the University of Washington Press,
P.O. Box 50096, Seattle, WA 98145-5096

Library of Congress Catalog Card Number: 96-70466

ISBN: 0-916857-09-3

Cover:
José Bedia, born Havana, Cuba, 1959
Ciclón vs Rayo
1994 (detail)

Contents

6 Introduction Aprile Gallant

8 The Vinalhaven Experience David P. Becker

23 Getting Graphic: Experimentation and the Vinalhaven Press Aprile Gallant

64 Chronology of the Vinalhaven Press, 1985-1996

68 Artists

80 Printers

84 Works Published by the Vinalhaven Press, 1985-1996

94 Glossary of Printmaking Terms Jeffrey P. Wolf

In Print: Contemporary Artists at the Vinalhaven Press is not a retrospective of the Vinalhaven Press. The Press has too many exciting years ahead of it for this exhibition to be the final word on its character. I prefer to see the exhibition as a "progress report," and the catalogue as a "sourcebook." The Press has been in operation for twelve years—not a significant amount of time in the life of a fine-art press, but a critical period for self-definition and development. Founded in 1984 by Patricia (Pat) Nick, the Vinalhaven Press is a place of experimentation, a workshop-like atmosphere that creates a special kind of print. Today, the Press continues to refine its mission and practice, and has made for itself a distinct presence in the world of fine-art printmaking.

The earliest years of a press are often taken up with developing traditions, working methods, and goals. For the Vinalhaven Press that evolution has occurred under a cloud of change. Beginning at the height of a printmaking boom in the 1980s, the Press survived (as many did not) the art market crash of the 1990s. In addition, methods of printing and reproduction of images have changed dramatically throughout the last half of the twentieth century. Technological advances in image making and dissemination—including increasingly refined computer graphics, Iris/Cactus prints, cyberspace, and international networks—have finally taken the focus off the multiple nature and mediated technology of traditional printmaking, much as photography has loosened its bonds as a method of reportage. This has allowed printmaking to take its place as an artistic, rather than reproductive, medium in the minds of the larger public. There will always be an interest in the technical craftsmanship of traditional print media, yet the proliferation of computers and networks will eventually return the focus of

viewing to the concept and the image rather than the mechanics of printmaking. The challenge to artists, publishers, and printers is to forge a new expressive identity for this once fully democratic medium. Combining "can-do" spirit and Yankee ingenuity, the Vinalhaven Press has developed a methodology and philosophy that will ride the wave of this changing perception of traditional printmaking and carry the Press into the twenty-first century.

In conceiving of this "progress report" of an exhibition, I have had to draw narrow parameters. Retrospectives of fine-art presses, by nature, are cumbersome entities. While they showcase the accomplishments of their subjects, the character of the press itself becomes diffused by the sheer number of works included. Since the unique character of the Vinalhaven Press is my subject, I have chosen not to include works by all twenty-six artists who have worked on Vinalhaven over the past twelve years. I have distilled the list of artists to those who meet two basic criteria: those who have had a long and fruitful relationship with the Press (Robert Indiana, Charles Hewitt, and Robert Cumming), and those who had limited print experience before their visit to Vinalhaven (José Bedia, Grisha Bruskin, Mel Chin, Komar & Melamid, Robert Morris, Alain Paiement, and Alison Saar). Although Peter Saul had made lithographs before his visit to the Press in 1995, the character of the work he did at Vinalhaven is so markedly different that it bears discussion. What these artists have in common is that the Vinalhaven Press challenged, and sometimes changed, their work. There is no Vinalhaven "look," due to the variety of the artists and the rotating schedule of master printers, but that is not the whole story. It is my hope that this catalogue and exhibition will be the introduction to that story.

Organizing an exhibition and catalogue is not unlike producing a fine-art print edition—filled with frenzied work, moments of inspiration, and loads of collaboration and encouragement. I have been blessed in this endeavor to have had the support and enthusiasm of Daniel E. O'Leary, director of the Portland Museum of Art, and the members of the Board of Trustees. Chief Curator Jessica Nicoll has provided essential guidance throughout the formation of this exhibition and catalogue. My colleagues at the Museum have given invaluable assistance, and I would like to acknowledge Michele Butterfield, Lorena Coffin, Stuart Hunter, Kenneth Wayne, and Gregory Welch.

This catalogue has been a major undertaking, and I would like to gratefully thank my able collaborators. David P. Becker provided an insightful essay on the history of the press, in addition to imparting invaluable professional advice throughout the project. Jeffrey P. Wolf, curatorial intern, was instrumental in assembling material for this publication. I am thankful for the considerable talents of my editor, Susan L. Ransom, Michael D. Ryus's handsome design of this publication, the sensitive and color-perfect photography of Melville McLean, and the wonderful documentary photographs of the shop by Christopher Ayers. Keith T. Shortall read early drafts of my essay, and provided useful insights. Barbara Sherburne provided invaluable editorial support. I am pleased that the McMullen Museum of Art, Boston College will be sharing this exhibition with us, and I would like to thank Nancy Netzer, director, and Stoney Conley, curator, for their efforts.

I would like to thank the following artists, individuals, and galleries for providing important information for the catalogue: George Adams, Lynne Allen, Barbara McGill Balfour, Jan Baum Gallery, David Beitzel Gallery, Peter Bodnar, Jim Cambronne, Pat Caparaso, Kathy Caraccio, Louisa Chase, Orlando Condeso, Condeso/Lawler Gallery, Robert Cumming, Patrick Dunfey, Chris Erickson, Ronald Feldman Fine Art, James Graham and Sons, William Haberman, Nancy Hoffman Gallery, Michele Juristo, Dennis Kardon, Julie Lazar, Marlborough Graphics, D.C. Moore Gallery, Alain Paiement, Kingsley Parker, Sylvia Roth, Sonnebend Gallery, Joan Thorne, and Brenda Zlamany.

The following lenders generously allowed the display of their works throughout the tour, and I would like to thank them for their support: Katherine Watson, director, and Mattie Kelley, registrar, Bowdoin College Museum of Art; Bruce Brown; Clifford Ackley, curator, and Anne Havinga, assistant curator, Department of Prints, Drawings, and Photographs, Museum of Fine Arts, Boston; Robert Indiana; and a private collection. Special thanks are due to Mel Chin, Randy Hemminghaus, Charles Hewitt, Jonathan Higgins, Robert Indiana, Anthony Kirk, and Helen Nagge for spending time talking with me about their experiences at the Press. Kathleen Beckert, Chris Clark, Alice Helander, Karoline Schleh, and Scott Smith taught me a great deal about the fine art of printing.

I am grateful for the support of KeyBank and L. L. Bean whose generous sponsorship of this exhibition and catalogue have made this project possible.

I have been fortunate to have spent three wonderful summers on Vinalhaven, where I was able to fully appreciate and investigate Patricia Nick's accomplishments. She has been an active collaborator throughout this project, providing information, support, encouragement, and boundless energy. It is to her, and to her future successes, that I respectfully dedicate this catalogue.

Aprile Gallant
Curator,
Prints, Drawings, and Photographs

The Vinalhaven Experience

The end of the 1990s is a particularly valuable time to examine and appreciate the achievement of a fine art print workshop that has been in operation for the past twelve years. This period has seen tremendous vitality and diversity within traditional printmaking as well as the rapid evolution of the World Wide Web and interpersonal cybermail. While the role of limited-edition prints may seem anachronistic to some, it is precisely the role of the print process as an exploratory discipline that can offer important lessons for appreciating the significance of these changes in contemporary culture and history. The printmaking process itself, as we have historically understood it, is in the midst of profound changes. While the traditional processes are still widely practiced and taught, the global nature of instant visual communication has seen more public, less elitist forms of repeated print images proliferate. More and more artists have been using the print medium in its most de-individualized, "industrial" guises, pushing definitions of "fine art" ever further and further. Artists have begun experimenting with "online" repeated images—virtual prints—as yet another boundary is explored and transgressed. The paradigm of image and/or text printed on paper has been turned on its head, or so it seems. While the essential principle of repeatability is still intact (including identical images on millions of television and/or computer screens), all other parameters are up for grabs.[1]

It is commonly accepted that the establishment of several collaborative printmaking workshops in the United States, beginning about 1960, created an atmosphere in which many innovative painters and sculptors tried their hand at the process. The results were so successful (a number of factors were operative here, not the least of which were cultural and economic) that prints began competing successfully in scale and visual impact with paintings and sculptural installations. Major limited-edition prints by Jasper Johns, Robert Rauschenberg, Frank Stella, Claes Oldenburg, and Jim Dine, for example, occupy prominent places in any survey of all art media during the 1960s and 1970s. This market and the prominence of the artists involved grew to such an extent, as Deborah Wye has pointed out, that whereas in the 1960s artists who were not already printmakers had to be coaxed to do prints, by the 1980s artists were often eager to try it, and in many cases realized the medium's potential for connections to the artistic ideas that occupy them.[2] One result of all this thought and activity was that printmaking no longer had to prove its viability as a fine art medium.

In addition to reflecting virtually all the visual concerns taken up by artists during the "postmodern" 1980s and 1990s, the printmaking process embodies properties that were and are at the center of many of those concerns: reproduction, reversal, mirroring, time, history, appropriation, technical mastery, collaboration, and distribution are only a few. This same period is concurrent with the activity of the Vinalhaven Press, which was founded in 1984, a date also notable for the production of the first Macintosh computer, which revolutionized the "virtual" production of printed art and text. Publishing innovative projects every year since then, the Press has been a full participant in all this fertile activity. The recent survey at The Museum of Modern Art of prints from this period, entitled *Thinking Print: Books to Billboards, 1980-95*, revealed many of these different concerns, perhaps most importantly highlighting the

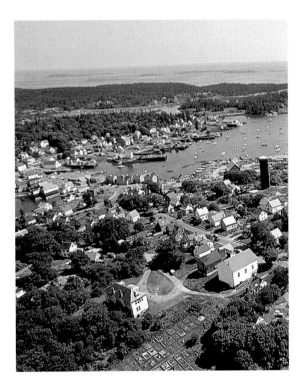

Figure 1:
Aerial photograph of Vinalhaven, 1992
The Vinalhaven Press building
is in the center foreground.
Photograph by Benjamin Magro

9

artist's preeminent role in determining the param-
eters of what may be considered "printed art."[3] One
Vinalhaven print, by Robert Indiana, was included
in this exhibition, and seven other artists repre-
sented in the survey have worked at the Press.

History of the Press

"It all started with the space." Thus does
Patricia (Pat) Nick describe the first concrete inspi-
ration for the founding of the Vinalhaven Press.[4]
The space in question was an abandoned turn-of-
the-century elementary school on the island of
Vinalhaven, where Pat had spent many summers
(and where her ancestors had settled some 200
years before). Inspired by a 1981 report advocating
the reuse of abandoned school buildings for the
arts, Pat saw an opportunity to fulfill her long-held
desire to become more professionally involved in
the direct making of art.[5] She was a printmaker in
her student days, graduating from the Boston Mu-
seum School, but had spent the intervening years
in museum administration rather than artmaking,
including stints as director of the Cedar Rapids Art
Museum, director of education at the Ringling Mu-
seum of Art, and director of the New England Mu-
seum Association. The current schoolhouse tenants,
the local chapter of the Veterans of Foreign Wars,
were willing to rent it, and in 1983 Pat suddenly
found herself wondering what to do with a very
large amount of empty space under a leaky roof
[Figure 2].

At the same time, the so-called "print renais-
sance" that had begun in this country in the early
1960s was still growing in visibility and vitality, and
a striking number of museums and galleries were
devoting exhibitions to contemporary printmaking.
As she found herself sharing a life between Man-
hattan, where much of this printmaking activity
was taking place, and Vinalhaven, Pat quickly con-
ceived of the essential model for the Vinalhaven
Press—a summer-long printmaking workshop on
the island in Maine and winters of preparation (and
sales) in Manhattan. She was of course following in

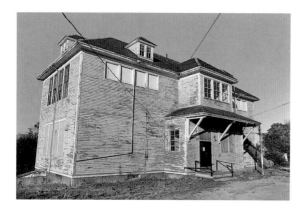

Figure 2:

(top) *George Washington school building,*
Vinalhaven, Maine
1996.

Photograph by Christopher Ayers

(bottom) *George Washington school building,*
c.1984.

Photograph ©1984 Gerard Murrell

the tradition of a number of other women entrepreneurs, such as June Wayne of Tamarind Lithography Workshop, Tatyana Grosman of Universal Limited Art Editions, Kathan Brown of Crown Point Press, and Judith Solodkin of Solo Press, but distinguished herself from most of these print publisher/workshops, which print year-round and are often located in the largest metropolitan areas. Instead, Pat wished to combine the productive, uninterrupted atmosphere of a removed summer setting with the access of a full winter "season" in New York's Soho district [Figure 3].[6]

Having thus made the decision to set up a professional printmaking studio, Pat set out to equip it. Coincidentally, the Maine Printmaking Workshop at Westbrook College became available, having itself been founded by John Muench only seven years earlier, and in January, 1984, Pat found herself possessed of an entire workshop: an etching press, a lithography press, twelve lithograph stones, and worktables, counters, stools, trays, paper cutter, blotters, and ink. She transported the dismantled shop by truck and ferry to the island and soon purchased other presses. Her acquisitions even included several valuable antique lithography stones that were discovered serving as paving stones on the terrace of an Irish pub![7] During this process, Pat also sought advice from a number of people, including master printers, gallery directors, museum curators, and other print publishers. Lynne Allen, a master printer and administrator at the Tamarind Lithography Workshop, was particularly helpful in describing the parameters of running a print publishing shop; she then filled a stint at Vinalhaven as a visiting printer during the summer of 1985.

After setting up the space on Vinalhaven in the summer of 1984 and testing the equipment, the Press embarked the next year on its first full summer, which Nick planned as an interrelated combination of educational and publishing functions. The first would be fulfilled by open workshops for "qualified artist-printmakers to work at minimal cost."[8] The second comprised a program of pub-

Figure 3:
Patricia Nick in the Vinalhaven Press office, 1996
Photograph by Christopher Ayers

lishing prints by seven invited artists who would be in residence for two-week periods. Managing the guest artists, six master printers, and one assistant printer—not to mention the paying participants—quickly proved not only a strain on the Press's resources, but also at times created disruptive personality conflicts between overlapping artists and printers. In spite of what she calls in retrospect a "big hootenanny," the Press did manage to finish a total of thirty print editions that summer, by Peter Bodnar, Mel Bochner, Carolyn Brady, Louisa Chase, Jonathan Imber, Joan Thorne, and Robert Indiana (as of the summer of 1996, the Press had accomplished 117 editions by twenty-six artists). Pat underwent much on-the-job training and now admits to a "ridiculously ambitious" program of publication at first, in which the Press produced several print editions by each of several invited artists. In a way, she felt driven to produce as much in a summer as other print publishers were able to accomplish in a full year, and soon ran into persuasive economic factors that forced her to scale back, even to sell some possessions, such as a Picasso linocut, to keep the presses running. Along with so many others, of course, the Press also was subject to the art world's economic "crash" in the early 1990s. Although she expresses an idealistic disregard for making money (after all, she had always worked in the non-profit business world), she came to realize that a publisher must pay attention to such factors in order to be able to continue to produce at all.

In choosing artists to work at Vinalhaven, Pat has been guided by a number of factors, including first and foremost the aesthetic qualities of an artist's work and whether it will translate well into the printmaking process. She speaks of favoring a "direct" look, when images "speak right up with a lot of strength and form." Although admiring of more subtle effects produced by other workshops, she does not pick them for her own. A print publisher spends an enormous amount of time in this search for a successful match between artist and the particular ideals of that press. Over the years, Nick has come to devote much more energy in choosing fewer artists, at times hosting only one artist a summer. After the frenetic activity of the first few years, she has directed her resources a bit more to artists who have not previously worked extensively—or at all—with printmaking; she still considers it important to produce a number of editions by each new artist she takes on. The initial search comprises recommendations from curators and dealers, studio visits, and of course plenty of gallery and museum viewing and looking through current art publications.

Once she has found artists she would like to work with, Nick begins the process of approaching them and their dealers, and then discussing potential projects. As much as two or three years can elapse between first contact and a residency at the Press. When an artist is unused to working in collaborative situations where the possibility exists of making "mistakes" in front of other people, a publisher may need to exercise considerable amounts of persuasion, though some artists are very excited by the camaraderie and experimental possibilities of a more open studio. And there is always the risk that an artist may arrive on the island and decide to work in a different way from that anticipated by the publisher; in these cases, the hope is that the results will be an exciting departure. As a combination printer-publisher, Vinalhaven Press requires that all invited artists must come to the island to execute the works to be published; Nick is not interested in merely paying for editions "contract" printed elsewhere. For the most part, the Press has tried to attract artists who are comfortable with the informal atmosphere that prevails on the island and in the schoolhouse studio.

From its first working summer, the Press has attracted artists of national stature. Robert Indiana is a year-round resident of the island and has supported the Press's mission from the start. Although his best-known prints previously were accomplished in silkscreen, which he favored for its satu-

rated colors and crisp edges, Indiana willingly returned to both lithography and etching for his print work at Vinalhaven. He has executed some twelve editions there from 1985 to 1992, including such intriguing works as *American Dream* and *Mother of Exiles* (both 1986), *Wall: Two Stone* (1990) [Figure 9], and *First Love* (1991). The first summer also saw Mel Bochner accomplish several bold, roughly spattered white-on-black aquatints that broke the rectangular format of traditional prints, and Louisa Chase begin working in etching after a very successful series of woodcuts executed at other workshops. Nick has consistently tried to persuade a mix of artists to work at Vinalhaven, from well-recognized painters who perhaps have not worked extensively in printmaking, such as Robert Morris and Leon Golub, to those younger artists whose work she feels would grow with exposure to the issues involved in the print medium, such as Alison Saar and José Bedia. The painter/printmaker Charles Hewitt has worked on his prints steadily and virtually exclusively at the Press for ten years.

Another time-consuming but crucial job for any print publisher is selecting the master printers to work with the invited artists. Vinalhaven Press is rather distinct from other workshops in this country in the number of master printers who have worked there. Having neither the schedule nor the resources to keep printers busy year-round, Nick at first devised a rotating system, finding that printers with their own studios often were willing to work for a couple of weeks or a month at Vinalhaven, with no printer working an entire summer. While certain printers, such as Orlando Condeso, Chris Erickson, Randy Hemminghaus, and Jonathan Higgins have been perhaps the most familiar faces in the shop, over the years other printers such as Maurice Payne, Kathy Caraccio, Brenda Zlamany, and Jim Cambronne have worked on specific projects. For the past five years, Hemminghaus and Higgins have been the master printers for all the editions, at times both working on several projects at once with artists such as Alison Saar and Mel

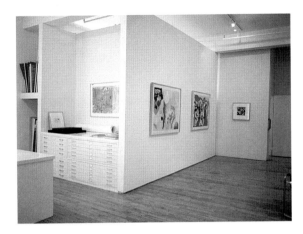

Figure 4:
Vinalhaven Press showroom,
New York, New York,
1991

Figure 5:
Workshop participants from the
Washington Print Club,
1992

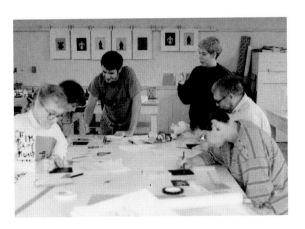

13

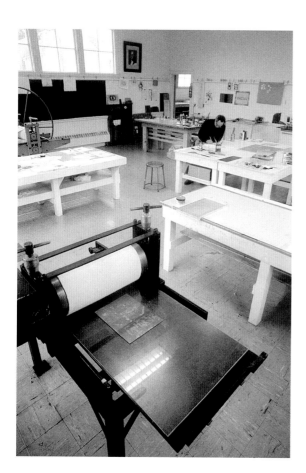

Figure 6:

Mel Chin in the intaglio shop,

Vinalhaven Press,

1996

Photograph by Christopher Ayers

Chin. The publisher's match of artist and master printer is crucial for a successful collaboration. In addition to a matter of personal compatibility, the technical knowledge necessary for achieving optimum results is formidable. A lithographic stone, for instance, is a notoriously fickle object, and a master printer must deal with factors of atmosphere, the quality of an artist's drawing, and the durability of the image on the stone over the course of a number of impressions in order to accomplish a successful edition.[9]

The selection process for artists and printers takes place primarily during the fall and winter, essential months of activity for the publisher, despite the absence of any printing. Her other job, perhaps her primary one, during the winter is to sell the Press's productions, and she finds it virtually essential to be in Manhattan to do so [Figure 4]. She must bring the finished print editions to the attention of museums and art collectors through exhibitions in her Soho loft space. She visits museum print curators, places notices in art journals such as *Print Collector's Newsletter* (now called *On Paper*), sends direct mailings of postcards advertising selected prints, and shows every November at the all-important International Fine Print Dealers Fair in New York, with upwards of seventy-five other dealers and publishers from the U.S. and Europe. Pat accomplishes these tasks virtually by herself, including the transfer of a great deal of material twice a year in her van between Maine and New York, often requiring several round trips.

The Press's achievement in a relatively short time has been impressive. Its prints have been included in the major recent surveys of contemporary printmaking, and the artists who have worked at the Press are even more numerously represented in these inevitably canonical overviews.[10] An early triumph was the awarding of a first prize at the 18th Ljubljana International Biennial of Graphic Art in 1989 for Komar & Melamid's *Peace I: Life of Tolstoy.* Vinalhaven Press was one of nine printer/publishers invited to represent the United States; its partici-

pation also included prints by Robert Cumming and Charles Hewitt.[11] Museums throughout the country have consistently acquired prints from the Press, and a complete edition archive has been established by the Bowdoin College Museum of Art, through which one impression of every Vinalhaven print enters its collection.

In concert with the inevitable commercial aspect of Vinalhaven's process, Nick has also consistently tried to bring an educational component to the Press's mission. She has pursued this in several forms, beginning with her original acquisition of the Maine Printmaking Workshop and the appropriate choice of a schoolhouse as the Press's home. She has maintained a steady commitment to having several graduate printmaking interns every summer to help the master printers, and when artist's schedules permit has continued to offer open workshops. She has recently set up a non-profit educational arm of the Press, the Vinalhaven Graphic Arts Foundation. Among other projects, Pat has eagerly sought to bring museum print curators, especially those who have never done prints, to the island for week-long workshops. Visitors have always been welcome, and museum patrons's groups from Washington, San Francisco, New York, and Portland have ventured to the island [Figure 5].

The Studio and the Prints

Certainly aware of the long tradition of painters who have worked on the Maine coast, Pat was convinced that Vinalhaven would be a great place for printmaker/artists to produce worthy work. The workshop's particular qualities have been extolled as encompassing "the lure of fresh salt air, the chance for delving into an intense period of creative work in a setting far removed from ordinary routine, and the assurance of a thoroughly equipped workshop."[12] In describing working at Vinalhaven versus other workshops, one artist has told this writer, with a mixture of respect and amusement, "there's nothing else to do on the island except work." The atmosphere of the island is

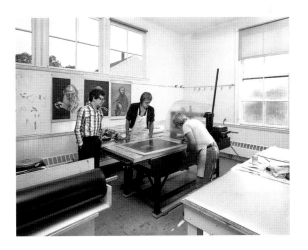

Figure 7:

left to right: *Aleksandr Melamid, George Bartko, and Julio Juristo in the lithography shop, Vinalhaven Press, 1986*

Photograph by Jon Bonjour

spare: there are no movie theaters, few shops, three or four small restaurants, one motel. It is a 75-minute ferry ride from the coastal city of Rockland, itself an eight-hour drive from New York. With about 1,100 year-round inhabitants, Vinalhaven is the largest working lobster harbor on the coast, and has not yet become a major tourist stop. For their part, the townspeople seem to have accepted the visiting printmakers and printers as fellow workers, and they have taken pride in notices by "off-island" media of the Vinalhaven Press's accomplishments.

The actual working space for the Press has been described as a "country cousin of a New York loft," with its high ceilings, large windows, and ample spaces—one of the prime contrasts is the absolute quiet outside the windows. The second floor consists of two very large studios (one for etching and relief [Figure 6], one for lithography [Figure 7]), which include such schoolhouse amenities as blackboards and a portrait of George Washington. The first floor contains a darkroom for preparing photo-etching plates, an archive storage space, and an office/gallery area. The studio windows look out above lush trees and an old graveyard next to a small cove; on sunny, clear days intensely blue skies punctuated by puffy clouds dominate the bright studio light. On stepping out the front door of the building, one is immediately aware of the building's site on top of an impressive granite ledge characteristic of the Maine coast.

The spare atmosphere of the island is applicable to the actual printing facilities and in a certain sense to the working process as well. While there are sophisticated presses for printing intaglio, relief, and lithography, the facilities are not especially high-tech, and the printers must cope without a convenient printmaking supply store anywhere near the island, not to mention Federal Express deliveries subject to ferry schedules. While the Press certainly tries to have enough materials at hand for proper printmaking, it does not strive to have dozens of varieties of printing papers, for instance,

preferring basic Arches and Rives papers and occasional use of colored "chine" papers applied underneath the printed image. The Press feels itself both limited and inspired to work with the materials at hand. Nick expresses a self-described "Yankee" attitude in declaring that they "never look for ways to be convoluted, preferring instead the most direct route to achieve the end result."

There is nothing smooth about a Vinalhaven print, a quality that occasionally appears in the work of other prominent print workshops. That is not to say that the workmanship is rough or unfinished, but that its deliberate, plainspeaking quality shows through in a consistent manner. If anything, Pat appreciates the tactile qualities of prints; she confesses to always wanting to rub her hand over their surfaces. Perhaps as a result both of the choice of artists to work at the Press and the carefully chosen variety of master printers who have collaborated there over the years, Vinalhaven Press prints do not exhibit the sameness of a clear "house style."

The subject of collaboration in contemporary printmaking has been extensively exercised in recent critical and historical commentaries, within the context of productions from many of the print workshops in this country since the 1960s.[13] This new development was a change not only from the traditional definition of a printmaker who alone executes an image on a plate and prints it, but also the traditional (mostly European) model of a large print workshop utilized by painters wishing to replicate their images, requiring the master printer to be virtually a robot executing the artist's desires. The new model often comprises a laboratory for much more overt collaboration between the image-maker and the printer. As one surveys the literature on this topic, it becomes "clearer" that there are a multitude of attitudes toward this relationship, even in this country—and, most importantly, that distinctions of "originality" and "authorship" have become blurred and actually less relevant in recent years.

At Vinalhaven, the collaborative process is cer-

tainly in operation, but one senses it in more subtle ways, perhaps as the result of the less pressured environment of the island and fewer individuals being involved in the studio space. Pat Nick chooses the invited artists and dreams about the project, but the artist always leads in all aesthetic decisions. There is a genuine hands-off spirit on the part of the Press that has allowed quite diverse artists to develop their ideas independently within the time of their residency, together with the master printers truly contributing to the artist's goal [Figure 8]. At its best, this relationship works superbly, as expressed by Frank Stella in discussing his own printmaking: "the printer is sort of everything in one sense. If you can't get along and you can't agree—if you're not doing it together—then there's no point in doing it, it doesn't work. You have to create a level of excitement to keep the project going, and if they're not into it and if you can't turn each other on, then it really doesn't work so good, it's no fun actually."[14] Master printer Jonathan Higgins says, "I consider it my responsibility to put in my two-cents' worth to help achieve what the artist wants to get." Ideally and often, each learns something new from each project and each other.

In any lengthy, often unpredictable process such as printmaking, the journey from artist's idea A to editioned print B is rarely a straight line, and the printer is crucially involved in realizing the full potential of printing plate, ink, and press. Nick has described occasional frustrations of deciding when to finally edition a print. With its unique ability to make printed impressions at any point within the development of an image on a plate, a single project may offer several opportunities to produce significant editions. The Press editioned two states of Robert Cumming's *Palette/Pedestal* prints, and for José Bedia it produced several variant editions printed on different colored papers. At times, however, certain effects that appear in the proofing stage will be too fleeting to reproduce well over the course of an edition.[15]

The Press will often begin a new collaboration by recommending that an artist do a group of monotypes, in order to loosen up from any preconceived notions, and perhaps achieve a stronger, more painterly imagery for the editioned prints. Even artists who have worked on print projects before coming to Vinalhaven have done this, often to striking effect. Robert Cumming's bold woodcuts *Odessa* (1988) and *Alexandria* (1989) developed out of monotypes executed when he was first in residence on the island. Yvonne Jacquette devoted all her time to producing an innovative series of nine pastel monotypes during her 1991 residency. The independent monotypes of Cumming and Bedia, for instance, have been powerful works in their own right. Working in the relatively rapid imagemaking-to-printed-impression timeline of monotype often helps curb an artist's initial impatience with the sometimes lengthy process of preparing plates for printmaking.

The artists who have worked at the Press have never been exclusively printmakers, and the resulting prints have never exhibited the sense of preciousness sometimes associated with the medium. Even such smaller-format etchings as the two series by Robert Morris, *Continuities* (1988) and *Conundrums* (1989), have a visual power that easily carries a wall. On the other hand, despite the search for grandeur that so delights some workshops, no project at Vinalhaven has approached behemoth proportions that require a car-crusher press to print. In contrast to a shop that will devote three years to developing sophisticated fabrication methods for a new experiment, the printers and artists at Vinalhaven will more likely take a trip to the island dump to delve for a piece of human history to run through the presses, as they did for Alison Saar's editions. There is always plenty of experimentation at the Press, but with the materials at hand, such as varied backgrounds for José Bedia's etchings of 1994, or the three-dimensional mounting of Alain Paiement's *Grand Amphitheatre—According to Horizon* (1989).

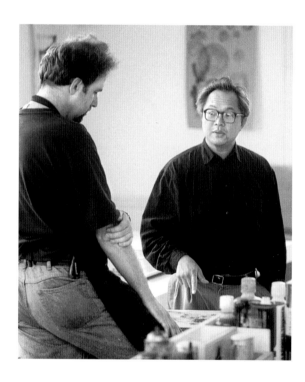

Figure 8:

left to right: *master printer Jonathan Higgins and artist Mel Chin consulting in the shop, 1996*

Photograph by Christopher Ayers

The Present and Future of Prints

While assuredly creating work at the center of the concerns of adventurous contemporary art, the Vinalhaven Press is still committed to the traditional means of making and publishing prints within the model evolved in this country by collaborative workshops over the last thirty years. Such a way of working has generally appealed more to painters than to the many conceptual artists who have recently exploited the parameters of prints, but who are less interested in the connoisseurship unique to hand-worked production methods.[16] This commitment entails considerable investment in materials and technical support for an artist who wishes to directly manipulate a printing surface to create significant printed works. The resulting impressions, usually printed on paper, are then issued in very small editions—ranging between ten and thirty impressions from each matrix, clearly not fulfilling the most democratic potential of the medium. Why continue with this arguably old-fashioned model? First and foremost, the uniquely rich qualities of woodcut, etching, and lithography are immediately apparent to the viewer who appreciates their physical presence—their "objectness," as it were—over and above the apparent imagery. Further, in an age when history is often disregarded, so-called "original" or "fine" prints created today represent and extend the five-hundred-year tradition of hand-worked prints of which artists are often very aware when they approach the printing plate or stone or woodblock. At Vinalhaven, Robert Morris consciously evoked Goya's potent precedent, in technique, format, and subject matter, and projects by Cumming and Bruskin comment on the precedent of text and book.

Prints have been both documentary and aesthetic objects—sometimes both at once—for their entire history, and the contemporary period is no exception, despite a relative decrease in emphasis on the specifically hand-made print.[17] Richard Field has commented on the resulting tension between these two aspects of printmaking today: "Since the

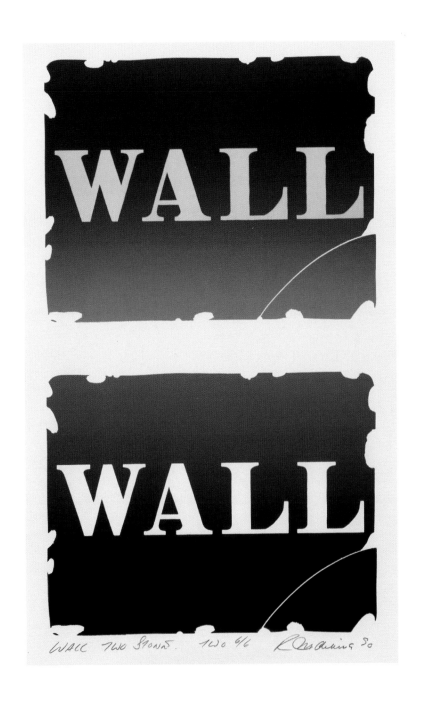

1960s . . . artists have very knowingly focused on the print's antipodal nature as both public (mass media) and private (stylistic) vehicles of replication." He describes the print as a "locus of uncommon balance" between different levels of representation and argues for the necessity of retaining the "aura" of the original print.[18] Riva Castleman has herself emphasized the role of printmakers as communicators, continuing the historical potential of printmaking as the most democratic medium and echoing Joseph Beuys's credo that "to be a teacher is my greatest work of art."[19]

The collaborative process that takes place between artist, printer, and publisher in a project of the sort that Vinalhaven strives for can lead to revelatory lessons for all, not least the artist, whose search for expressive imagery of course is the central focus of the endeavor. Pat Nick has described the Press's process as a commitment, "not just of its resources, but an unconditional agreement to believe in, and support, a quest."[20] And, despite her occasional amused memories of the ups and downs of running a print publishing workshop, she declares that she doesn't "regret a minute of it. [The Press has exceeded] my wildest expectations."

David P. Becker

1 The concept of repeatability derives from William Ivins's famous definition of a print as an "exactly repeatable pictorial statement." (W.M. Ivins, Jr., *Prints and Visual Communication* [Cambridge: Harvard University Press, 1953; reprinted Cambridge: MIT Press, 1968], p. 2).

2 Quoted in *Print Collector's Newsletter* 27 (May-June, 1996), p. 59.

3 See Deborah Wye, *Thinking Print: Books to Billboards, 1980-1995* (New York: The Museum of Modern Art, 1996), p. 11.

4 In addition to printed interviews and articles on the Press that I have drawn upon for the following narrative, I am especially indebted to Pat Nick for her generous cooperation with my research, which has included much hospitality at her Vinalhaven home. This essay has also benefited greatly from interviews with Pat on June 27 and 28, 1996, and with Jonathan Higgins on July 7, 1996. I have also learned much from shorter conversations with artists and printers over the past seven years of visits to the Press.

5 Educational Facilities Laboratories, *The Arts in Surplus Schools* (New York: Academy for Educational Development, 1981). The study was supported by the Design Arts Program of the National Endowment for the Arts.

6 Her decision was wryly noted in the announcement of the Press's establishment appearing in the influential journal *Print Collector's Newsletter*: "an island twelve miles off the coast of Maine . . . is not the most obvious place to set up a print workshop." *PCN* 16 (November-December 1985), p. 172.

7 The most favored lithographic stones come from a region in southern Germany no longer producing them. As stones are not used any more for commercial printing purposes, artists often have had to scrounge for those abandoned by older printing firms (see Clinton Adams, *American Lithographers 1900-1960* [Albuquerque: University of New Mexico Press, 1983], p.

207.) The pub story is reminiscent of Tatyana Grosman's discovery of two stones in her own front yard (Esther Sparks, *Universal Limited Art Editions—A History and Catalogue: The First Twenty-Five Years* [Chicago: The Art Institute of Chicago, and New York: Harry N. Abrams, 1989], p. 18.)

8 When it opened, the Press was known as Vinalhaven—The Maine Printmaking Workshop; this quote comes from a press announcement of the first summer's program.

9 Pat Gilmour, *Ken Tyler and the American Print Renaissance* (New York: Hudson Hills Press in association with Australian National Gallery, 1986), p. 14. Odilon Redon, who made some of the richest lithographs ever printed, called the stone "cantankerous and peevish, like a capricious and nervous person" and preferred to deliver his preliminary drawing to a professional printer to transfer to the stone before he would draw on it himself (Tedd Gott, *The Enchanted Stone: The Graphic Worlds of Odilon Redon* [Melbourne: National Gallery of Victoria, 1990] p. 29).

10 See especially Deborah Wye, *Committed to Print: Social and Political Themes in Recent American Printed Art* (New York: The Museum of Modern Art, 1988), in which one Vinalhaven print and three artists were included; Trudy V. Hansen, David Mickenburg, Joann Moser, and Barry Walker, *Printmaking in America: Collaborative Prints and Presses, 1960-1990* (New York: Harry N. Abrams, 1995 [Exhibition organized by Mary and Leigh Block Gallery, Northwestern University]), in which one print and seven artists were included; and Wye, *Thinking Print*, in which one print and eight artists were included.

11 See Leslie Luebbers, "Women of the Press," in *International Biennial of Graphic Art* 18 (Ljubljana: International Centre of Graphic Art, Moderna Galerija, 1989), p. 297.

12 Bruce Brown, in *The Vinalhaven Press: The First Five Years* [exh. cat.]

(Rockport, ME: Maine Coast Artists Gallery, and Lewiston, ME: Museum of Art, Bates College, 1989), p. 4.

13 Among many others, excellent discussions of this topic include Gilmour, *Ken Tyler*, pp. 30-36; Hansen essay in Hansen, et. al., *Printmaking in America*, pp. 32-69; and Susan Tallman, *The Contemporary Print from Pre-Pop to Postmodern* (New York and London: Thames and Hudson, 1996), pp. 7-31. A survey in *Print Collector's Newsletter* 23 (January-February 1993), pp. 210-18, listed 192 print workshops operating at that time in the U.S.

14 As quoted in Gilmour, *Ken Tyler*, p. 125.

15 For a discussion of the evolving development process of six print editions at Vinalhaven see David P. Becker, "The Proof is in the Printing; or, Perusing Process," in *Vinalhaven at Bowdoin: One Press, Multiple Impressions* [exh. cat.] (Brunswick, ME: Bowdoin College Museum of Art, 1992), pp. 5-18.

16 Wye, *Thinking Print*, p. 15.

17 Implicit in this essay has been the restrictive discussion of so-called "fine" art. If one is to be democratic in speaking of prints, such categories as reproductive museum posters and images from more popular culture (cowboy art, religious imagery, stars of television series, etc.) must also be included in the broad definition of those printed objects that people choose to hang on their domestic walls. Those cultural icons do not exist only to serve as inspiration for postmodern printmakers.

18 Richard S. Field, "Replication as Creativity in the Prints of Jennifer Bartlett," in *Jennifer Bartlett: A Print Retrospective* [exh. cat. by Sue Scott] (Orlando: Orlando Museum of Art, 1993), p. 2.

19 Riva Castleman, *Printed Art: A View of Two Decades* (New York: The Museum of Modern Art, 1980), p. 31.

20 Becker, *Vinalhaven at Bowdoin*, p. 4.

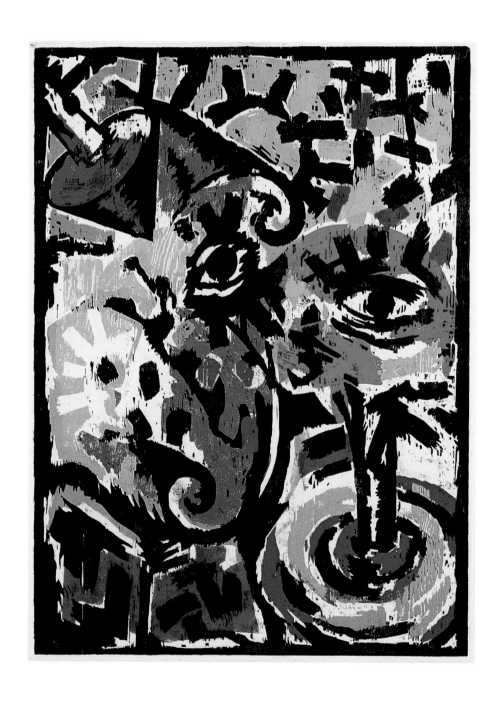

Figure 10:

Charles Hewitt, **Iago II,** *1986*

Getting Graphic
Experimentation at the Vinalhaven Press

Printmaking has developed two distinct strains since the American print "boom" of the 1960s—one that is concerned with the aesthetic development of historical methods of printmaking, and another that seeks to redefine the nature of the medium. The official definition of a "print" has also changed dramatically over the past thirty years. Initially, there was a strong desire to separate the "original" print, where the artist was directly involved in the process, from the "reproduction," where the artist's input was limited. Since the 1960s, a new generation of artists has focused on the multiple nature of prints rather than on the use of traditional materials. Technological advances in image making, including increasingly refined computer graphics, the proliferation of photographic media, and inexpensive methods of printing, have expanded the boundaries of contemporary printmaking. This trend, however, has not halted the production of lithographs, intaglios, woodcuts, and silkscreens, which artists use much as they use traditional methods of painting and sculpture. Publishers who focus on historical methods of printmaking have carved out a distinct place in the contemporary art world and continue to expand the boundaries of traditional print media.

The Vinalhaven Press is one such publisher. Located on an island fifteen miles off the coast of Maine, the Press's focus on hands-on production of traditional prints was formed partly by necessity

(technological amenities are few), but mostly by choice. The choice is that of Patricia Nick, founder and director of the Press. This "back-to-basics" approach, however, does not signal an aesthetic conservatism. While some presses have developed a distinctive "look," a visual quality that signals the hand and taste of certain printers or publishers, the Vinalhaven Press has resisted such uniformity. The workshop atmosphere, lack of permanent staff, and varied choice of artists are partially responsible for this situation. So, too, is the fact that the Press resisted developing a specialty medium. It has produced an equal number of woodcuts, lithographs, and intaglio prints from its inception. The greatest factor, however, is the strong current of experimentation that has become the Press's hallmark. Such an approach is to be expected of artists who are new to traditional methods of printmaking. One of the distinctions of the Vinalhaven Press is that it challenges the novice and the initiate alike.

In trying to characterize the identity of the Press, it is crucial to closely examine the circumstances, as well as the products, of the artists who have worked there. There are three distinct types of artists who have visited the Press over the past twelve years: experienced printmakers, artists who frequently cross media yet are not known for their graphic work, and artists who are relatively new to printmaking.

Experience

Experienced printmakers know their way around a print shop. Whether they have printed their own work (like Charles Hewitt), have a relationship with other print shops (like Peter Saul), or are known for a large body of graphic work (like Robert Indiana), their first-hand knowledge of graphic art places certain demands on a new press. The key is to provide these artists the freedom and the challenge to create graphic works of art that stand apart—to reintroduce them to the possibilities of the medium.

One of the initial attractions of printmaking for the painter Charles Hewitt was its communal atmosphere. Although he studied printmaking in college, it was at The Printmaking Workshop in New York in the mid-1970s that Hewitt renewed his involvement with the medium. It was also there that he met Anthony Kirk, a Scottish master printer who steered the painter toward woodcut.

In the mid-1980s, printmaking developed a new life with the rise to prominence of artists, like Hewitt, who developed an expressive abstract style based on figurative content. The "Neo-Expressionists," as they came to be called, were particularly attracted to the directness of the woodcut. Drawing upon the historical precedent of German Expressionists like Erich Heckel and other artists of *Die Brücke*, as well as the powerful influence of a new generation of German printmakers such as Anselm Keifer and Georg Baselitz, American artists embraced the woodcut as the perfect print medium to express a more direct and personal vision. The Neo-Expressionists pulled printmaking back from the technological advances of the 1970s, restoring it to its most basic elements. Although this impulse was present in printmaking culture during the 1970s, it emerged in the 1980s as a major force. Kirk and Hewitt began working together in the mid-1970s and produced several woodcut and drypoint editions.

When Pat Nick went to Kirk's studio in 1985 to talk to him about becoming a master printer for the Vinalhaven Press's second year, the printer shrewdly invited Hewitt to the meeting and prominently displayed one of the woodcuts they had printed together. Nick left that day with a printer *and* an artist. Hewitt's direct style of painting and his love of the "unmediated" print—woodcut and drypoint—mirrored Nick's stated preference for "strength and form."[1]

Upon arrival on the island, Hewitt was left largely to himself—a prospect he relished—while Kirk worked with Robert Indiana on another project.[2] Vinalhaven, and Pat Nick's gentle prodding, led Hewitt into new territory. After he devel-

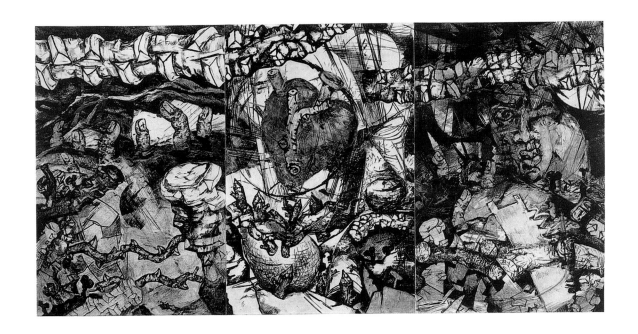

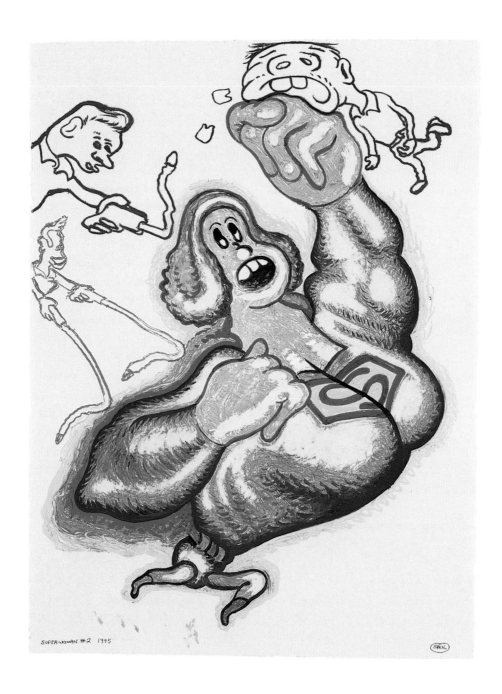

Figure 12:

Peter Saul, **Superwoman #2***, 1995*

oped three woodcuts during the first two weeks, Nick challenged him during his final week to "make one print—one print with life." The resulting work, *Iago*, editioned in three different states, was radically different from Hewitt's other projects at the Press and the work he had done up until that point. Hewitt's works are populated by overt and private symbols—fists, hearts, buoys, nails, and metal or wood bars—which convey both artistic and personal struggle. In *Iago II* (1986) [Figure 10], with its complex layering and exploitation of the texture of strong drawing over fine Asian paper, the artist focuses on conveying his message without figurative elements. The only recognizable figures, the eye and buoy, are counterpoints to the work's strong marks and colors. His first experience at the Press turned Hewitt in a new direction, and, as he says, "threw my painting off for a year."

While printing, by its nature, is an indirect pictorial system, where the image is transferred rather than directly laid down on a surface, the "fight" of the block or the plate is seductive to a self-avowed "physical" painter like Hewitt. For this reason, the artist limits himself to woodcut and drypoint, eschewing acid-based processes such as etching or aquatint. Drypoint and woodcut focus Hewitt's energies on the properties of line and shape. This is not to suggest that Hewitt's drypoints are delicate. *The Heartland* (1993) [Figure 11], a massive triptych, carries a similar visual power to *Iago II*. The added attraction of drypoint is the ability to change the plate. Lines can be burnished out, shapes scraped from view—creating a richly patterned story that can be printed and reprinted many times. Two of the panels of *The Heartland*, in fact, were reworked from plates Hewitt had previously editioned at the Press—*Keeper* (1988) and *Black Pearl* (1988). The burnishing and scraping also add depth and texture to the work, revealing the plate's "memory." Instead of using aquatint for shading, which the artist finds too "perfect," Hewitt scraped down the center of the middle plate and drew the details of the heart over this section.[3] Working at

Vinalhaven has allowed Hewitt the freedom and support to take chances. Over the past eleven years, he has published twenty editions with the Press, as well as a series of ten monotypes.

Although Pat Nick is attracted to the strong, direct mark-making at the heart of Hewitt's work, she is equally drawn to artists who have an aggressive, and often political, approach to content. There can be no greater contrast between the visual styles of Charles Hewitt and Peter Saul. Saul began his career in the early 1960s on the fringes of the "Pop" movement. Although he was in Europe at the time, and largely unaware of developments in American painting, his use of commercial subjects such as comic-book superheroes and everyday appliances allied him with Pop. His own brand of cynical irreverence, however, set him solidly apart.[4] Saul quickly declared his independence, developing a cast of grotesque and cartoonish subjects, which he painted in slick Day-Glo colors in a distended surrealistic style. By the late 1960s, Saul had set himself the task of violating as many artistic and social taboos as possible—*Mad Magazine*-style depictions of Vietnam atrocities, violent race relations, and sexual politics became his favored subjects.[5] Saul also threw his considerable energy toward the art world, painting such subjects as *Double DeKooning Ducks* (1979), a version of Willem DeKooning's famous *Woman* paintings featuring the Disney character Donald Duck, and *Francis Bacon Descending a Staircase*, featuring Baconesque figures in Marcel Duchamp's famous composition.[6] Saul's disturbing subjects and aggressively irreverent style inspired the Chicago Imagists, a group of painters including Roger Brown, Jim Nutt, and Karl Wirsum, who adopted grotesque cartoon-like imagery during the 1970s, yet Saul remained (largely by choice) on the fringes of American art throughout the 1980s.[7]

It was Peter Saul's inclusion in the 1995 Whitney Biennial that reintroduced his work to Pat Nick. Nick remembered seeing Saul's work on a number of occasions, but the flurry of publicity around the exhibition at the Whitney and a concur-

rent installation at the George Adams Gallery brought him to the forefront of her mind. The artist's "bombastic" imagery and iconoclastic views appealed to Nick personally, while his bold painting style touched an aesthetic nerve.[8]

Saul made color lithographs during the 1970s, mostly with Landfall Press in Chicago. The artist's work at Vinalhaven is radically different from these prints, either from their lack of color or choice of media. Generally, Saul is more concerned with content than process, so the medium of photo-etching seemed ideally suited. *Mona Lisa Throw-Up* (1995) [Figure 13], and three companion pieces, *Soft Watch on the Toilet*, *I'm Splitting*, and *Goddess*, were transferred to copper plates from the artist's line drawings. The absence of color in these works, while surprising, puts the focus on one of the artist's preoccupations—his self-described "wrong drawing."[9] *Mona Lisa Throw-Up* benefits particularly from this treatment. The medium of etching, perfected by Europeans in the sixteenth and seventeenth centuries, is given full focus, depicting an icon of Italian painting indecorously "losing her lunch." The fact that the original drawing was transferred photo-mechanically, coupled with the elegant plate tone, gives the work a wonderfully bogus authenticity, which bolsters Saul's attack on the inviolability of this artistic icon. Even Marcel Duchamp, in his famous *L.H.O.O.Q.*, a copy of the DaVinci painting with a mustache drawn on it, did not go this far. Saul expanded this theme in a large-scale painting, executed after his residency on Vinalhaven, depicting the Genovese lady again in a moment of gastric distress.[10]

Saul also executed a series of monotypes at Vinalhaven that relate more closely to his goddess paintings of the 1990s. *Superwoman #2* (1995) [Figure 12], and her alter-ego, *Bizzaro Superwoman* (1995), a variant with square features and breasts, refer to both Saul's interest in "the battle of the sexes" and the influence of comic books.[11] These buxom superheroines, endowed with huge forearms and tiny hips and legs, battle goofy-looking ineffectual men armed with guns whose bullets bounce off their brightly-colored auras. Despite their heroic attributes, these women are far from ideal. Gap-toothed and ill-proportioned, they appear to be mindless fighting machines knocking out innocuous opponents. These monotypes are more "painterly" than the artist's paintings, which are almost three-dimensional with their hard-edged layers of Day-Glo pigment. In this quality, they reveal the "painter" in Saul, and hearken back to his early work of the 1960s, down to the red drips in the lower left corner of *Superwoman #2*.[12] While Saul has always used shading in his paintings, the white highlights in the figure, messy color mixtures, and obvious drawing mark these monotypes as distinctly handmade works.

There are few more consistently graphic bodies of work than that of Robert Indiana. Although he studied printmaking early in his career, at the School of the Art Institute in Chicago, Indiana burst upon the printmaking scene with the silkscreen *New Glory Penny* (1963) commissioned by *Art in America* magazine as a project to "redesign American currency" for an exhibition at the Guggenheim Museum in New York. As the youngest artist commissioned, Indiana was assigned "the lowly penny."[13] The strong graphic sense in the work, coupled with his bold use of color and compactness of expression, would define the artist's work for the next two decades.

Indiana's inspirations are myriad, ranging from the personal (his family and childhood in Indiana, and early contact with the hard-edge colorist Ellsworth Kelly) to the popular (road signs and commercial advertising). His distinctive typography was gleaned from early sculptures executed at his studio in Coenties Slip, New York, in the early 1960s. The narrow width of the found beams which make up his totemic "herms" necessitated words of less than five letters, while his discovery of brass shipping stencils distinguished their form.[14] In addition to his distinctive visual forms, Indiana is also known for his concise use of words, which

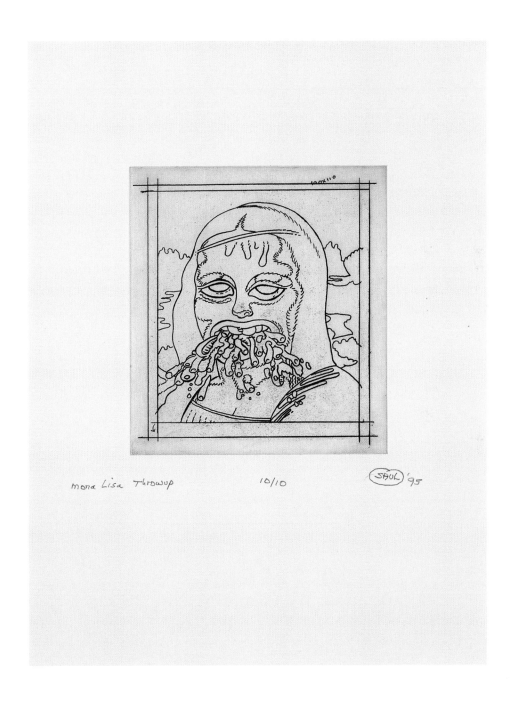

mona Lisa Throwup 10/10 SAUL '95

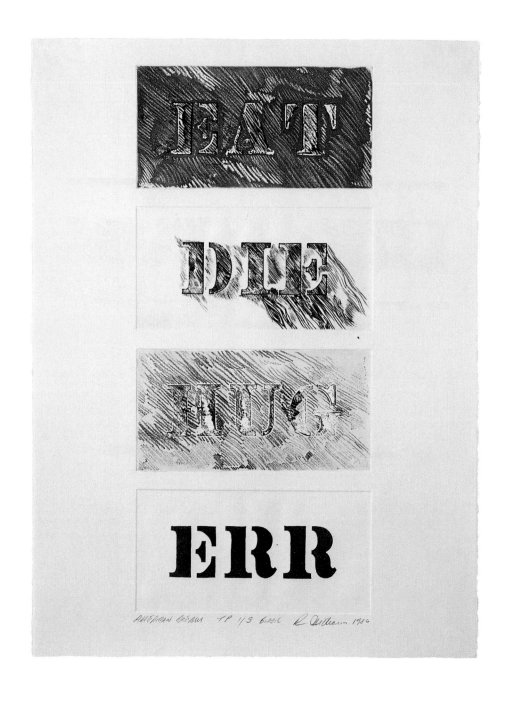

Figure 14:

Robert Indiana, **The American Dream***, 1986*

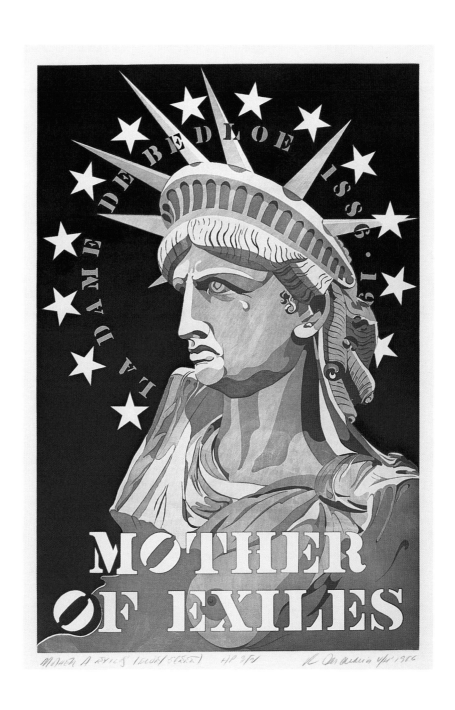

has been likened to "concrete poetry."[15] His repetition of certain words, and the constant reformulation of their placement and juxtaposition to other words and images, adds layers of meaning to otherwise simple phrases or concepts. It seems natural that Indiana, a prominent artist and resident of Vinalhaven since 1978, would become involved with the Vinalhaven Press. This happenstance also reunited the famous Pop artist with a medium from his past: intaglio printing.

The only printmaking medium not found at the Vinalhaven Press is silkscreen. This is a personal choice on the part of the publisher, who feels that a similar color saturation, with the added bonus of greater depth, can be achieved better with lithography.[16] By depriving Indiana of a staple of his artistic language, the crisp outlines and bright flat colors inherent in silkscreen, working at the Press allowed him to step outside many of the assumptions surrounding his graphic work.

When Indiana embarked upon his first solo project with the Press, he decided to sharpen his intaglio skills on a series of small test plates.[17] The resulting work, *The American Dream* (1986) [Figure 14], became more than just an etching primer. This series of words—EAT, DIE, HUG, ERR—have long been a part of the artist's vocabulary.[18] So, too, has the notion of the "American Dream," a concept that pervaded Indiana's Depression-era childhood. The translation of this theme into etching (hard- and soft-ground), aquatint, and drypoint, presents an intimate graphic work that reflects the artist's developing optimism on the subject. The directives of human life, to "EAT" and "DIE," are tempered by the human actions, to "HUG" and "ERR." The stacked composition brings such an interpretation to the forefront, as does the "human" hand of the etching and drypoint needle. Pat Nick asked the artist to allow her to edition this powerful work, a true example of the valuable energy of the experimental process.

The American Dream prepared Indiana for *Mother of Exiles* (1986) [Figure 15], a large intaglio work executed at Vinalhaven that same year. The artist had been preparing sketches and models of the composition since May. Yet, in keeping with his celebratory treatment of his subjects, he waited until late June, near the Statue of Liberty's centennial, to show Pat Nick and master printer Anthony Kirk his plans.[19] While *Mother of Exiles* retains certain recognizable symbols from Indiana's vocabulary— stars, stencil lettering, and iconic subject matter— the gradations of aquatint and scraping produce a level of subtle shading that has not been seen in the artist's work for over twenty years. The closest precedent for the bare-breasted bust of Liberty in her maternal guise is a diptych of the artist's parents painted between 1963 and 1967. These symbolic portraits, *Mother* and *Father* [Figure 16], refer to the artist's birth, his parents' wanderlust, and their individual characters. Indiana's colorful, bare-breasted mother-figure is contrasted with a monochromatic father, both juxtaposed with the prize family possession, a Model T Ford, as much a symbol of the American Dream as his parents's rootlessness.[20] Another layer of subtext within the print *Mother of Exiles* is the distinctive form of the letter "O" in the prominent legend at the bottom of the print. This reference to the artist's world-famous "LOVE" composition allies the themes of universal and maternal love, monumental academic public sculpture, and American history. While this work has been seen as a "rejection of radical stylistic change," on the part of the artist, Indiana's return to an expressive form of intaglio printing is a surprising shift for an artist well-known for his hard-edged shapes and saturated colors.[21] His choice of technique, coupled with the complex layering of the personal and the popular, imbues *Mother of Exiles* with a softness and pathos that is unique in the artist's body of work. On the subject, Indiana simply says: "I think Liberty has a great deal to cry for."[22] An additional consideration was the demotion of the Statue of Liberty as a maternal figure. Immigrants are no longer freely welcomed into this country, as recent history and legislation have aptly

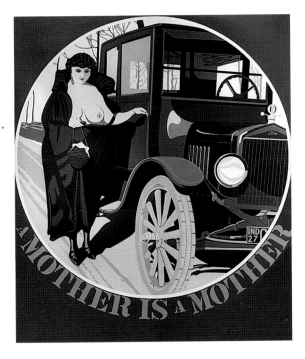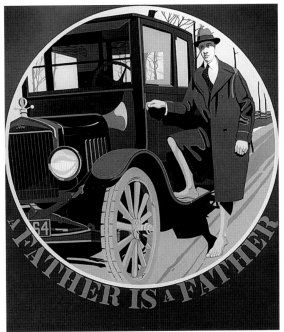

Figure 16:

Robert Indiana, **Mother** *and* **Father**, *1963-1967*

oil on canvas, 70 x 60 inches (each)

Collection of the artist

Photograph by Eric Pollitzer

demonstrated. The loss of this vital meaning has turned Lady Liberty into an empty and over-exposed public icon, and her animate sadness on this turn of events is fully appropriate for a celebration of her hundredth birthday.[23]

Experimentation

Publishing prints in the 1990s is considerably different than it was in the last decade. Today, artists rarely define themselves as painters, sculptors, or printmakers, preferring to let ideas take precedence over a close alliance with prescribed materials. Art produced during the 1990s has often featured material and conceptual experimentation, stressing the effectiveness of its communication and content rather than visual forms or techniques. The idea of the singular artist has also fallen into question. A multitude of artists's collectives found new prominence during the late 1980s, a trend which continues into the 1990s. All of these trends bode well for widespread acceptance of the "collaborative" nature of printmaking, yet they also present certain challenges to the future structure and execution of traditionally-based, limited edition prints. While an artist who is not tied to one medium may be more adventurous, he or she may also chafe at the limitations of traditional print media. This puts a high level of responsibility on the master printers to ensure that the viability of the print, as well as the wishes of the artist, are not violated.

Robert Cumming's work provides a perfect transition between the realms of experience and cross-media experimentation. A self-proclaimed "artist of 'things'," he often works simultaneously in photography, painting, printmaking, sculpture, writing, and performance.[24] Switching media allows Cumming to meditate on an object from all sides: examining its visual, aural, linguistic, historical, and cultural permutations, as well as its visual structure and function. The resulting works carry rich and varied associations.

Cumming had an early interest in art and natural talent as a draftsman. He trained at the Massa-

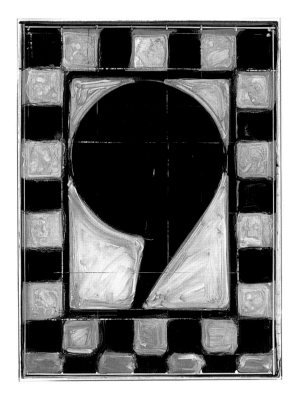 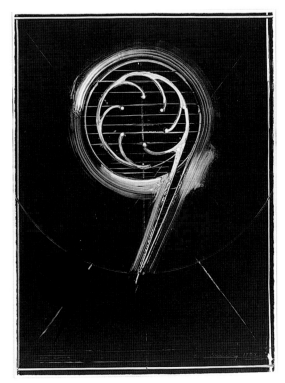

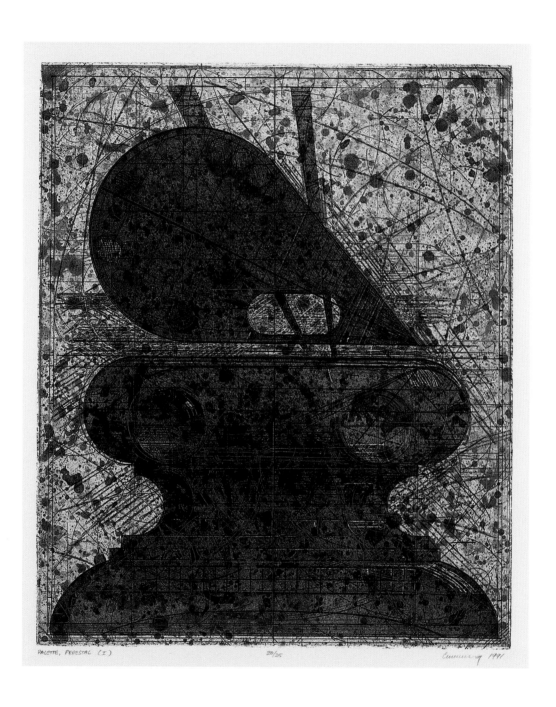

PALETTE, PEDESTAL (I) 20/25 Cumming 1991

Figure 18:

Robert Cumming, **Palette/Pedestal,** *1991*

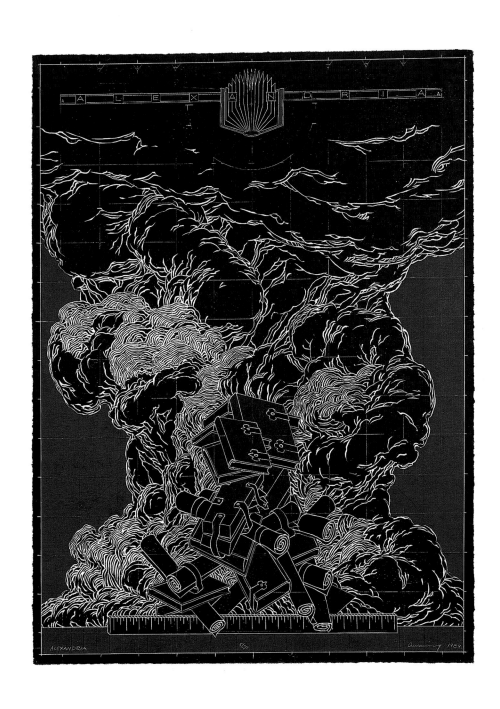

chusetts College of Art and the University of Illinois during the mid-1960s, working in a variety of media, but felt that school had not prepared him to "make things that looked like they belonged to the things of the real world."[25] Thus began a time of intensive study where Cumming not only developed skills, but also encouraged his own predilection toward material experimentation. Cumming's subject is often a mundane object, which he juxtaposes with other objects or words, examines diagrammatically, or recontextualizes. The underlying theme of these visual investigations is perception, and the slip-space between image and idea. The artist's approach to objects has been likened to that of an archaeologist who is charged with creating a complex history from simple physical evidence.[26]

Pat Nick had followed Cumming's work in all media for some time. His inclusion in the 1986 Brooklyn Print Biennial, coupled with work she had seen at Lorence Monk Gallery and Castelli Graphics, finally spurred her to contact him about working at the Press.[27] Cumming spent four summers (1987, 1988, 1989, 1991) on Vinalhaven, creating a body of work in all four major print media (intaglio, monotype, woodcut, and lithography) as well as a circular system of mutating symbols.

One potent figure in the artist's vocabulary is the comma. This emblem first came to light in the artist's book *Equilibrium and the Rotary Disc* (1980). The first story in this collection relates the musings of an unidentified man, who, after discovering the remains of a mosquito between the pages of a dictionary, creates an elaborate connection between the insect and the surrounding punctuation:

A few hair-line leg segments [of the mosquito] still stuck to the paper. They resisted the fingernail removal. They obscured no major words, had no effect on syntax, except for the stop-motion effect produced on the planar paper space surrounding a critical comma. If the comma were set spinning in motion it might flick off little ink traces that would look like this. A mosquito, drawn to it by its tiny little noctur-

nal whine, might be cut to ribbons by the comma's sharply pointed black tail invisibly spinning; chopping a half-dozen tiny little limbs; line segments scattered helter-skelter across the rough paper fiber.[28]

Through the series of seemingly disconnected stories that follow, the comma mutates into a rotary saw and a whirlpool. Since 1980 this basic figure has spawned a number of variants, including the guitar pick, skull, and palette.[29] Once a form has taken hold in Cumming's vision, references that connect it and distinguish it from its other variants quickly follow. For example, the "creative" power of the artist's palette, and the "destructive" connotations of a death's head skull are diametrically opposed, although they carry the same basic shape.[30] Cumming has built a dynamic lexicon of objects and their referents, which freely change meaning throughout his work.

Among the first prints the artist executed at the Vinalhaven Press were a series of monotypes including *Comma Series* (1987) [Figure 17]. Monotypes, as David Becker has noted in this catalogue, are often used at the Press to "loosen up" the artist, as well as to develop ideas to be dealt with in other media.[31] *Cut-Out Comma/Apostrophe* and *Cool Comma*, which appear on the respective left and right of the triptych, display the active spinning motion of the artist's vision of motorized punctuation. *Cut-Out Comma/Apostrophe* serves the double function (as an apostrophe) of connecting the work to others as a contraction or possessive (as in can't or artist's). The backward orientation of the apostrophe can be attributed to the fact that the image was transferred from another surface, yet this discrepancy also adds an interesting twist to the reading of the composition. The central panel, *Check Comma* performs as an object, or picture, framed by a checkerboard pattern, with a clear background and no discernable movement. Cumming plays with the perception of dimension—the two spinning three-dimensional commas flanking an inert two-dimensional comma—while he

also draws with the negative, scraping the image out of a clear field of teal-colored ink.

The comma later transformed itself into a palette in a tour-de-force etching, *Palette/Pedestal I* (1991) [Figure 18]. *Palette/Pedestal I* also feeds into Cumming's love of word-play, juxtaposing two "P" words that leave the viewer pondering their connection. While the palette and pedestal are recognizable as objects, the drawn lines and granite-textured background declare the absence of a third dimension. The palette has lost its function as a creative implement and has become a symbolic image of artistic production. The combination of objects that refer to other media—painting and sculpture—in a printed work of art further complicates the search for a simple explanation of the scene, as does the fact that both the palette and pedestal are equally on display although one sits atop the other.

Measurement, draftsmanship, and perception reign throughout Cumming's Vinalhaven prints. *Alexandria* (1989) [Figure 19], a woodcut that grew from the artist's experimentation during that same year with reductive monotypes, depicts a heap of books and scrolls at the base of an intricately patterned cloud. A drawn grid marks the measurement of the composition, and an unnumbered ruler sits at the bottom of the picture. The word "Alexandria" emerges from the spine of a book at the top of the print, extending across the upper margin. The juxtaposition of "Alexandria" with the scrolls and cloud refer to the destruction of the great classical library in that city during the seventh century. The form of the cloud also recalls the mushroom of an atomic explosion, as well as resembling the cloud in Albrecht Dürer's woodcut *St. John Devouring the Book*. Both of these visual cues invoke an apocalypse—one biblical, the other historical—conveying horror at the destruction of books, which hold both language and knowledge.[32] All of the visual components, from the blank measurement of the ruler to the beautiful pattern of the woodcut cloud, also feed directly into the perception of the viewer. Each element leads back to individual perception,

stimulating the incessant questioning and associations each viewer must work through to find meaning in any picture.

Mel Chin, who spent three weeks on the island in 1996, also uses art to challenge the assumptions and perceptions of his viewers. Chin, an internationally-known conceptual artist, is preoccupied by a variety of topics and concerns: alchemy, the environment, social and political issues, and human communication, among others.[33] Key to the artist's process is extensive research, which bodes well for his ability to adapt to printmaking. Chin is a natural collaborator who both feeds and feeds off of the enthusiasm of others. His initial inspiration for a project is often nothing more than a simple phrase or idea. Research fills in detail, adding layers of meaning to images and objects. Given Chin's method of working, it was vital that he be allowed the time and resources to fully develop his ideas. Nick responded with a bold move, canceling workshops, tours, or projects that might have taken up shop time, and scheduling two master printers, Randy Hemminghaus and Jonathan Higgins, to work with the artist.

A pivotal inspiration for Nick's decision to invite Chin to work at the Press was his use of sculptural form and the attention he paid to materials in installations such as *The Operation of the Sun Through the Cult of the Hand* (1987). This installation combined the materials of alchemy, the scientific forms of the solar system, and the mythological associations of the planets to create a series of evocative objects that combine these three areas of study.[34] It also made Nick aware of one facet of Chin's artistic style: the creation of multivalent, sensual objects that work in tandem toward a larger goal. Chin has described this approach as a "Venus flytrap": the beauty of the work seduces the viewer into a close examination of the piece, where he or she encounters the artist's encoded fragments.[35]

This approach is evident in one of Chin's first projects at the Vinalhaven Press. *The Language of Birds* [Figure 20] grew out of the artist's experi-

ments with etching, and was inspired by the poem *Manteq at-Tair [The Conference of the Birds]*, by the twelfth-century Persian poet Farid un-Din Attar. Attar's poem relates the story of a meeting amongst the birds of the world who are in search of a "king." They undertake a quest to find this leader, under the guidance of a bird called the hoopoe, whom they question throughout their journey. At the end of the voyage, they find that the king they seek is themselves.[36]

Manteq at-Tair is based on the teachings of sufism, a mystical Islamic doctrine of which the poet was a proponent. The tenets of sufism were not written down, as it was believed that the only way to learn them was a prolonged apprenticeship with a spiritual leader. It is an inward system of belief; the earthly realm is considered God's "shadow," and only through reflection into the self (as a "shadow" of divinity) can a follower be led to a recognition, and "self-annihilation" through alliance with God.[37] The word "shadow" is key to Chin's conception of the poem. While on Vinalhaven Chin wrote "SONGS TO THE SHADOWS. . ." in the margins of a copy of Dick Davis's introduction to a translation of the poem.

Rather than a congress, Chin's print *The Language of Birds* displays a deep break. Disembodied bird heads at the margins call toward a black shadow that divides the center of the paper. This configuration also suggests a lack of communication—the birds of the world become the people of the world, individually calling, in different voices, for life's meaning. It is not necessary to know the genesis of Chin's images to make sense of their message. The open, squawking mouths of the birds, separated from their fellows and pointed toward a limitless void, is an evocative image that few could misinterpret. *The Language of Birds* is the ultimate Venus flytrap, an exploitation of the sensuous materials of printmaking to impart a pointed message.

In his recent work, Chin has gravitated toward large conceptual collaborative projects, a tendency that began with one of the artist's more (in)famous installations—and, in fact, his first multiple. The *Revival Field* project (1991-ongoing) began in the late 1980s, when Chin read an article that discussed the properties of plant "hyperaccumulators," which absorb toxic materials. Recognizing the "poetic" possibilities of being able to clean dangerous landfill sites organically, Chin formed a partnership with Dr. Rufus Chaney, an agronomist at the United States Department of Agriculture, to develop a project that would traverse the boundaries of art and science.[38] Chin assembled the first *Revival Field*, a precisely arranged plot of six varieties of hyperaccumulators, at the Pig's Eye Landfill in St. Paul, Minnesota, in 1991. The layout of the site follows ritualistic practices gleaned from the artist's study of a variety of ancient cultures. The plants, which absorb several kinds of toxic materials, were harvested and incinerated, yielding pure metals that were then recycled.[39] The success of this project, and its realization in other places, has focused the artist's mind on the future of land reclamation. *Revival Ramp* (1996) [Figure 21], a print Chin executed at Vinalhaven, is based on a drawing the artist did in Europe while working on building a *Revival Field* in Holland. This complex print traces the course of ecology from the perspective of human history. At the bottom is a vision of a healthy environment before the industrial revolution, expressed in the red-brown group of trees taken from *A Copse of Trees* (c. 1500), a drawing by Leonardo DaVinci. A red circle marks a small plant—an early hyperaccumulator. As the ramp ascends, we encounter homesteads amidst felled trees and large factories belching smoke. The ramp displays both the air and earth, which darken as it moves upward. At a crucial bend in the ramp sits a plan of Chin's *Revival Field*, whose hyperaccumulators lighten the concentration of toxic materials in the soil. Here, the ramp splits into three parallel paths—one connects to a vision of the destruction of the waters and ozone layer (upper left), a second leads to a diseased and degenerated group of

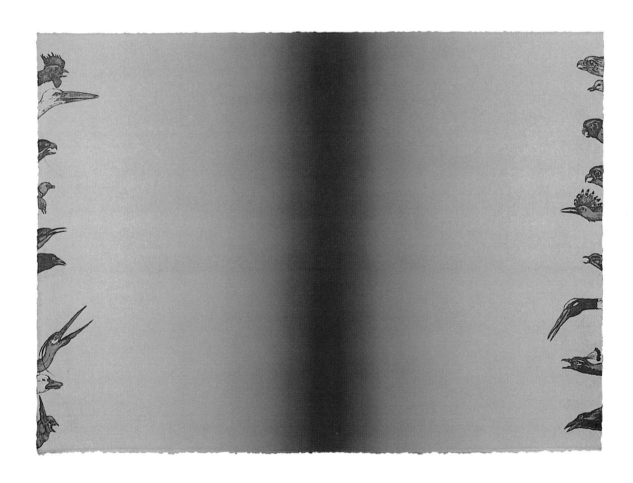

Figure 21:

Mel Chin, **Revival Ramp**, *1996*

trees (center), and a third follows a grid of *Revival Ramp*s to a return to DaVinci's idyllic trees. Chin's vision is neither optimistic nor pessimistic, and his didacticism is hidden in the sensuous lines and careful rendition of his drawing.

Many of Chin's current projects, like *Revival Field*, *State of Heaven* (begun 1991), or *In the Name of the Place* (begun 1996) have placed Chin in the dual roles of director and participant.[40] While the theoretical basis and the process of execution of all of these projects is primarily in the artist's hands, the nature of Chin's global-scale conceptual art often separates the artist from direct encounters with his materials. His time on Vinalhaven allowed Chin to connect physically with his materials and the process of creation.

Conceptual art, by its nature, finds its expression in many different forms. It is no wonder that the artists who have shown the most willingness to challenge the ideas and resources of printmaking at Vinalhaven have primarily been conceptual artists. In 1986, Pat Nick visited the Ronald Feldman Gallery in New York searching for interesting artists for residencies during the Press's second summer. Her visit coincided with an opening of new work by the Soviet-born team Komar & Melamid. Komar & Melamid were the first conceptual artists invited to the Press.[41]

Vitaly Komar and Aleksandr Melamid met as students at the Stroganov Institute of Art and Design in Moscow. As the progenitors of Sots Art, a hybrid of American Pop and Soviet Social Realism, the pair became leading figures among Soviet dissident artists. Like its American cousin, "Sots" both mocked and celebrated the culture of its host country—in this case, the monuments of Communism and depictions of god-like leaders and heroic peasants.[42] The artists combined traditional painting with conceptualism, creating large-scale depictions of elements of Soviet culture rendered with broad humor and biting satire. For their first project at Vinalhaven, Komar & Melamid invoked Leo Tolstoy, the famous novelist and icon of Russian/

Soviet culture, in an eight-panel print project, *Peace I: Life of Tolstoy* (1986) [Figure 22].

In this project, Tolstoy's novel *War and Peace* becomes a reference both to the author and to the repetitive cycle of history. A reductionist picture of history can be devised through the vehicle of the novel's title: War and Peace **and** War and Peace **and** War and Peace, repeated infinitely. Komar & Melamid subvert this continuum by replacing "War" with "Tolstoy," and varying the second half: "Tolstoy and Mushroom **and** Tolstoy and Fish. . .," to depict a fictitious life for the celebrated author.[43] *Peace I: Life of Tolstoy* won the prestigious first prize at the 18th Ljubljana International Biennial of Graphic Art in 1989.

On their return to Vinalhaven in 1990, Komar & Melamid embarked on two separate projects that would invoke their native and adopted countries. A series of monotypes, *The Double Revelation*, combines superimposed images of Christ and Josef Stalin with printed texts, in Russian and English, of the thirteenth Revelation from the Bible. The texts, printed side-by-side, relate a warning of the coming of an evil being in the disguise of a saint. Oil pastel monotype drawings of beasts, apples, candles, and other forms partially cover the text, which is flanked by merged double images of Christ or Stalin. The overprinting of the figures makes them monstrous. In *The Double Revelation: Candles II* [Figure 23], the left image of Christ has only one eye, while the right has three, leaving doubt in the mind of the viewer as to whether the figure is saint or beast. The drawn sections add to this perception. The candles are a raging inferno, while the apple in *The Double Revelation: Apple I* swarms with vicious-looking worms. These compositions mirror the confusion of Soviet attitudes toward religion during the Communist era, pitting the "false opiate of the people" against the terrors of Soviet history.

The second project of that year, *Hot Heavy Sears* (1990) [Figure 24], takes square aim at American culture and the myths of value and personal

Figure 22:

Komar & Melamid, **Peace I: Life of Tolstoy**, *1986*

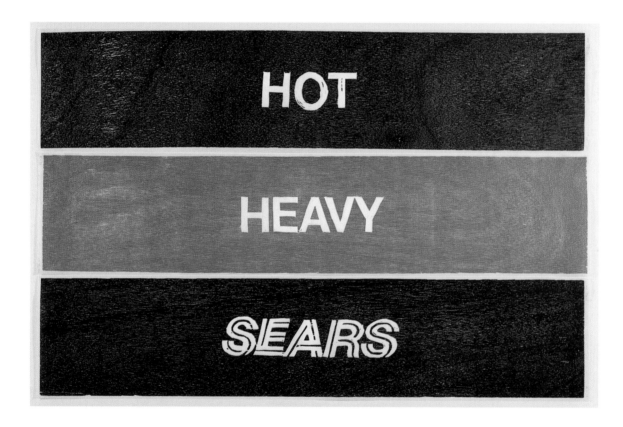

Figure 24:

Komar & Melamid, **Hot Heavy Sears**, *1990*

choice. This inventive project features a series of woodcuts on 10 x 48-inch strips, each emblazoned with a single word ("OH," "SO," "HOT," "HEAVY," "DARK," and the corporate logo for "SEARS"). An accompanying brochure, written in the jargon of advertising, extols the "heavy-duty beauty" of the prints and the extra value of a customized product [Figure 25].[44] Buyers are invited to select any combination of words, in four choice wood-grain colors (Honey Maple, Praline Mahogany, Blond Oak, and Wild Pecan), to make their own work of art. This tongue-in-cheek project is a precursor to Komar & Melamid's demographic survey painting, *America's Most Wanted* (1994), which is an image developed from information gleaned from public-opinion polls. The answers to a series of simplistic and leading questions on what individuals most desire in a work of art were recorded and converted to statistics. The most popular responses were then rendered in paint.[45] The resulting work, like *Hot Heavy Sears*, parodies the consumer culture and overwhelming marketing that lies at the heart of American business.

Not all artists with a history of working in conceptual art made conceptual prints at the Press. Robert Morris came to Vinalhaven focused on the material properties of printmaking and with a specific goal in mind: to master the etching process. The resultant portfolios, entitled *Continuities* (1988) and *Conundrums* (1989), each contain five prints rendered in soft-ground etching and aquatint.

Morris is perhaps best known for his eclecticism. Beginning first as an abstract painter in the 1950s, he has created a diverse body of work in the fields of dance, performance, minimalism, process art, conceptual art, and expressionist painting.[46] Although many of the artist's works have displayed a concern with the body, figures did not reappear in Morris's art until the 1980s. Beginning with the *Firestorm* drawings (1982), large-scale works on paper composed of swirling patterns and visible traces of skeletons and body parts, the figure re-inhabited the artist's work alongside a new apocalyp-

Figure 25:
brochure for **Hot Heavy Sears**, *1990*

tic imagery. Pat Nick was struck by the power and scope of Morris's *Firestorm* drawings, which she first saw on exhibition at The Museum of Modern Art in New York in 1987, and approached the artist, who had long been on her wish list.[47]

By this time, Morris had expanded his graphic vocabulary in a series of manipulated photographs, incorporating drawn and painted elements, framed with sculptural reliefs. These works contemplate the historical course of human conflict with its brutality, destruction, and mindless cruelty, as well as the threat of war in a technological age.[48] Two sides of the artist's work—his meditations on war, and his use of art historical models—would come together in his work on Vinalhaven.[49] Nick prepared the shop for the scale and scope of a print work that would capture the energy of Morris's *Firestorm* drawings, contracting with a virtuoso intaglio master printer, Orlando Condeso. When the artist arrived on the island, however, he brought with him books on the etchings of Goya, and it quickly became clear that Morris had another project in mind.

The Spanish artist Francisco y Goya Lucienties (1746-1828), was court painter for Charles IV, and witness to the devastation of Spain during the Napoleonic conflicts (1808-1814). Goya's talents as a satirist, as well as his belief in the Enlightenment, are well documented in two series of prints entitled *Capricios [Caprices]* and *Disparates [Follies]*. The artist is recognized for his powerful expressions of cynicism and despair in the late etchings *Los Desastres de la Guerra (Disasters of War)* and his late "black" paintings.[50] Goya's mastery of the etching technique, coupled with the conviction and strong statement of his content, made him the ideal inspiration for Morris's first print portfolio.

Continuities [Figure 26] combines images from Goya's and Morris's artistic vocabularies. This series of five prints is marked by the presence of a heap of corpses visible in the foreground. This repeating motif, the "continuity" that ties the portfolio together, is juxtaposed with figures from the "black"

paintings, a series of works Goya painted on the walls of his home in suburban Madrid between 1820 and 1824. These are among Goya's most pessimistic images, populated with senseless violence (the *Cudgel Fight* visible in Figure 26), and scenes of mythological destruction (*Saturn Devouring His Children*). All starkly depict the evils of human nature—violence, blind self-preservation, and the mentality of the mob. Morris places these loaded images in the context of their results—horrific human destruction personified by the mass of dead bodies in the foreground. This one thread in *Continuities* powerfully brings the historical horrors recorded by Goya and the present fear of world destruction face to face.

Conundrums [Figure 27], a portfolio executed during Morris's 1989 visit to the Press, continued this exploration of Goya's imagery with the addition of text. Each print in Goya's published portfolios contained a title that commented ironically on the scene. Morris turned this commentary into a visual element in side-by-side diptychs pairing evocative phrases with bleak images. "DESPAIR/OF YOUR/SELF/DESPAIR/OF YOUR/COUNTRY," accompanies a representation of a woman skinning another figure with a large knife. The isolation of the word "SELF" mirrors the placement of "COUNTRY," addressing the nature of personal responsibility in the plight of the larger world. The dark shadows and the precision of the artist's drawing add to the impact of this powerful work. Morris would revisit the images in the *Conundrums* portfolio in a series of paintings in 1990, adding color and expressionistic painting to the realization of this theme.[51]

The Shock of the New (Printmaker)

Being the first press to publish the graphic work of an accomplished artist is an exciting gamble. Conventional wisdom places sculptors, with their sensitivity to materials, and painters, with their two-dimensional vision, as the artists whose ideas will most likely translate well into intaglio,

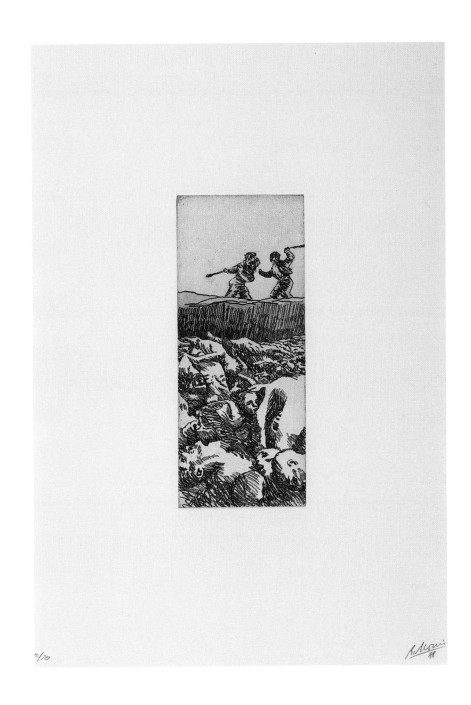

Figure 26:

Robert Morris, image from the portfolio **Continuities,** *1988*

4 9

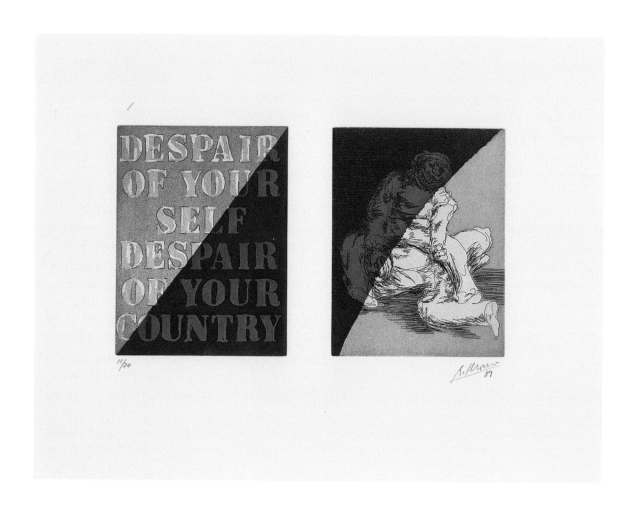

Figure 27:

Robert Morris, image from the portfolio **Conundrums,** *1989*

woodcut, or lithography. A consistent preoccupation with strong forms and mark-making, coupled with a willingness to experiment, are also signs that an artist's work will be successful in traditional print media. While an experienced publisher can often imagine how an artist's concerns might translate into print, the exact form is often unclear.

So it was when Pat Nick was approached by Tara Reddi, director of Marlborough Graphics, about co-publishing a print project. Nick was immediately drawn to the work of the Soviet expatriate Grisha Bruskin.[52] Mystical and didactic, the artist's paintings and sculptures are populated by iconic figures, ranging from hearty model socialists to angels and hybrid human/beasts. Paramount in the artist's vision is an exploration of the function of myth in Russian society. Bruskin neither condemns nor celebrates Socialist thought—he simply accepts it as reality and explores the underlying belief system. The form of the book often provides a structure for Bruskin's work, as a vehicle for communicating both mythology and truth.[53] Due to the scale of the artist's paintings, and his more than life-sized sculpture, woodcut seemed the perfect medium for Bruskin's first print project. While he initially embraced the idea, upon his arrival on the island the artist was transfixed by the material properties of etching.

The resulting portfolio, *Lexica* (1992) [Figure 28], contains five prints populated by figures similar to those that appear in Bruskin's paintings. The portfolio format is in keeping with the structure of these paintings, in which several panels bearing groups of figures are laid out in a grid. By themselves, the figures are meaningless details, but when combined they create private, magical myths.[54] The small size of the prints is deceptive: each has a visual impact that would have been diffused on a larger scale. The figures are silhouetted against a rich aquatint ground bearing horizontal lines similar to writing paper. The writing, here picked out in opaque white against a red background, is purposefully unintelligible. The artist does not wish to imply that either the figure or the text explains the other, rather suggesting that they work as intertwined visual elements.[55] Bruskin's meticulous etching technique makes these prints stand out in relief. The patterns of white dots, the letterforms, and the rich black aquatint on the body of the figure display the precision of the metal, and almost appear to be cut out of some rigid, uninflected material. The portfolio format of this work, in an elegant case, stretches the boundaries of Bruskin's investigation of the book form by introducing the mechanics of turning the page. The artist worked for three weeks on these prints, often discarding plates in order to achieve perfection. While Bruskin's exactness presented certain challenges to master printer Randy Hemminghaus, other projects at the Press have posed structural, rather than perceptual, difficulties.

During a trip to Canada with Art Table, a national association of professional women in leadership positions in the visual arts, Pat Nick and her colleagues visited The Power Plant, a non-profit contemporary art space in Montreal. The exhibition on view, *Amphitheatres*, featured work based on photographic media, ranging from sculptures to viewer-interactive installations, by Alain Paiement, a young Québec artist virtually unknown in the United States. Impressed by the scope, complexity, and variety of Paiement's work in this exhibition, Nick invited the artist to make his first print at the Press in the summer of 1989.[56]

During the 1980s, Paiement executed a series of works based on systems of topographical mapping. These installations, which included elements of painting, photography, draftsmanship, and architecture, examined the way scientific, visual, and artistic meaning is produced and perceived. Maps are generally used to represent three-dimensional spaces in a two-dimensional format. A topographical map takes this premise one step further by including measurement of the third dimension.[57] The artist's early installations investigated aspects of the landscape, different physical and visual perceptions

of cloud formations (*Waterdampstrukturen* [1985]), and the nature of the scientific construction versus the human experience of man-made landmasses (*Beyond Polders* [1987]). With *Amphitheatres*, he turned his attention toward architecture.

An amphitheater, as used by the Greeks and Romans, is a site of spectacle. In more modern times, these large, round rooms with staggered seating have been used for teaching, giving members of the audience equal access to the activities below. The print Paiement executed on Vinalhaven, *Grand Amphitheatre—According to Horizon* (1989) [Figure 29], and the photographic work on which it was based, *Grand Amphitheatre: Horizontal Planisphere*, translate the space of the Grand Amphitheatre at the Sorbonne in Paris into a topographical map charting one viewer's experience. To make these works, Paiement took a series of photographs from a fixed position in the upper gallery of the Grand Amphitheatre. These photographs record the entire visible space in horizontal blocks from the center of the ceiling to the floor. Mounting the work was a key procedure. Instead of following the concave form of the amphitheater itself, Paiement created a topographical map, stressing an essentially flat medium representing a three-dimensional space. The form of the topographical map is most often used to show details, such as mountains or valleys, on large land masses that cannot be seen by the human eye. Paiement's deliberate collapsing of a human space, however, sacrifices perceived experience in favor of the panoptic view. The only intact point of view is the horizon line, which remains unbroken, while the top is split and the bottom torn, like an eviscerated globe. As Barbara Fisher has pointed out in the brochure that accompanied the *Amphitheatres* exhibition at The Power Plant, this procedure mirrors the dissection of a cadaver, an educational, scientific demonstration historically done in an amphitheater space.[58]

Grand Amphitheatre—According to Horizon is one of the few prints done at Vinalhaven that directly translates a previous work by the artist. The challenge of the print's making, however, was irresistible to Pat Nick, and its rendition in print adds another layer to an already complex work. The artist's photographs were transferred photomechanically to etching plates, and printed in strips for final assembly. The etching process takes the image one step further from the photograph, compounding the division between the work and the actual space, as well as producing multiples that can be exhibited simultaneously in radically different contexts.[59] Since his time on Vinalhaven, Paiement has expanded his print vocabulary. He is currently working on several new editions that will encompass digital as well as manipulated photographic imagery.[60]

Like Alain Paiement, Alison Saar also stretched the boundaries of traditional printmaking and the resources of the Press's staff. A nationally-known sculptor, Saar was born into an art-centered family. Her mother, Betye, has had a long career making sculptures, totems, and altars of found objects that refer to African-American history and a variety of religious rites. The artist's father, Richard, is a conservator of African and Pre-Columbian art, and it was while working with him that Alison became intrigued by non-Western art, direct carving, and "the power of materials."[61] Although Alison Saar's work draws upon these familial roots, she is best known for her over-life-sized carved figures, which are made of urban detritus, including nails, old tin ceilings, tile, glass, and pottery shards.

A precedent for this artmaking strategy can be found in Saar's native Los Angeles. Watts Towers, a system of concrete structures studded with broken glass and discarded objects built by the Italian immigrant Simon Rodia, was an influence on both Betye and Alison.[62] After studying art history at Scripps College, and graduating with an M.F.A in 1981 from Otis Art Institute, Alison moved to New York City, making a name for herself throughout the late 1980s and 1990s with a series of high-profile museum exhibitions.

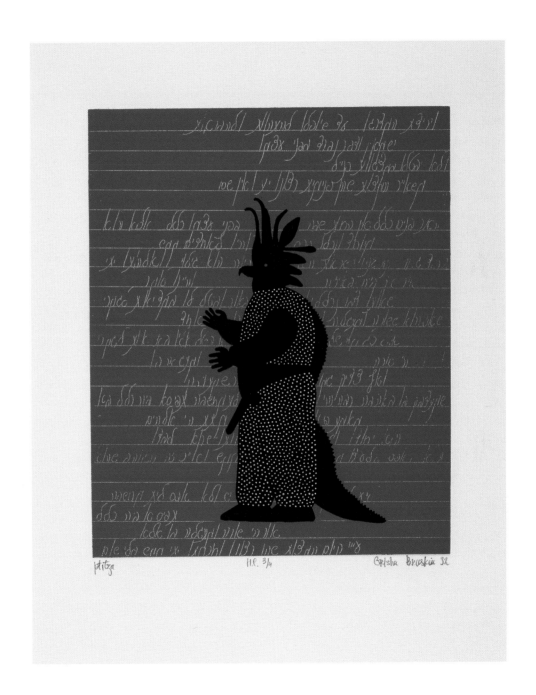

The idea of inviting Saar to Vinalhaven was sparked by a note from David Kiehl, curator of prints and drawings at the Whitney Museum of American Art in New York. Kiehl sent Pat Nick a small woodcut the artist had done in conjunction with her exhibition *Slow Boat* at the Whitney branch at Philip Morris in 1992. Nick followed up by attending several of Saar's exhibitions and finally met her during a showing of the traveling installation *Catfish Dreamin'* in Washington, D.C.[63] Saar first visited Vinalhaven in 1993, after a stint as a resident artist at the Skowhegan School of Painting and Sculpture. Although Betye Saar had been a printmaker when Alison was a child, the younger Saar had not widely experimented with the medium before visiting Vinalhaven.

While many artists come to the Press with drawings and ideas, Saar came armed with materials, including a selection of discarded shoe soles and a piece of tin ceiling. The artist's use of found materials is rooted in her interest in history, and the idea that materials are possessed with memories that can inform and expand their artistic use. Many of the elements of Saar's work on Vinalhaven are based in past works, most notably *Blue Plate Special*, an image derived from her sculpture *Salome* (1988). *Salome* was the artist's meditation on the Biblical story of St. John the Baptist, who was beheaded at the request of Salome in revenge for his rejection of her. This composition inspired two very different mixed-media prints, an etching and lithograph and a powerful three-dimensional woodcut [Figure 30]. In the latter, the blue severed head, displayed prominently on a platter, is surrounded by a decorative scarf printed on Japanese paper and inserted into two small slits just below the edge of the platter. The scarf was printed from a lithographic plate, on which was transferred a pattern from the back of an old rocking chair scavenged from the Vinalhaven town dump. The title ironically connects the grisly scene to a dinner special at an American diner, and the elegant presence of the fluttering cloth counterpoints the expressive

cutting of the block. Woodcut, with its relation to the physicality of Saar's sculpture (she often uses a chain saw to cut her massive figures), and its directness when printed, is an ideal medium for the artist's imagery. On a thematic level, *Blue Plate Special* easily crosses many historical and cultural contexts. Besides its link to the artist's previous work on the subject of Salome, this sacrificial scene can be seen in the light of the human devastation of war, street violence, or a variety of historical legends. The transportation of a biblical theme into modern times through non-Western figural traditions reflects Saar's interest in updating human history through references to "universal mythology."[64]

Saar returned the following year to continue projects she had started the previous summer. *Snake Man* (1994) [Figure 31], which the artist had begun in 1993, is based on her early sculpture *Snake Charmer* (1985). The addition of media other than the coarse grain of woodcut adds to the dynamic surface of this print. The textured pattern of the figure's body was printed from a panel of discarded linoleum, which had weathered and cracked with age. When the linoleum split under the pressure of the press, the matrix was inked and transferred to a lithographic plate. The red snake, lips, and nipples of the figure are printed in woodcut, so that the thick ink stands out, boldly punctuating the surface. The blank eyes and immobility of the body give the figure an archaic feel, as if it is an ancient statue or a shaman. Saar's works often draw upon the traditions of folk and non-Western art and a variety of cultures. While she has studied the forms and myths of Celtic, Mexican, Haitian, African, Asian, and American societies, Saar reacts intuitively to the creation of her work, rather than composing formalized pastiches.

Another Vinalhaven artist who shares Saar's interest in the melding of various myths and cultures is José Bedia, a self-described "occidental" Cuban now living in Miami.[65] This strategy of creolization is natural to both artists; Saar's varied artistic experiences and mixed ethnic heritage and the nature of

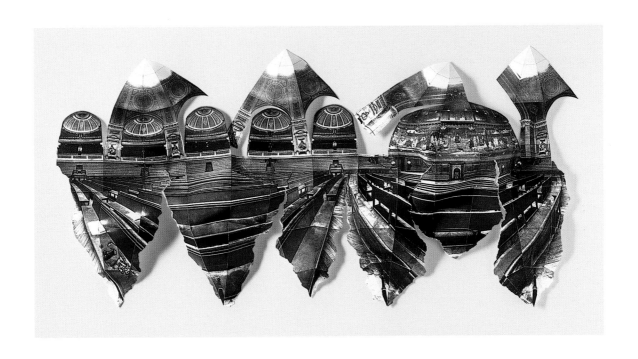

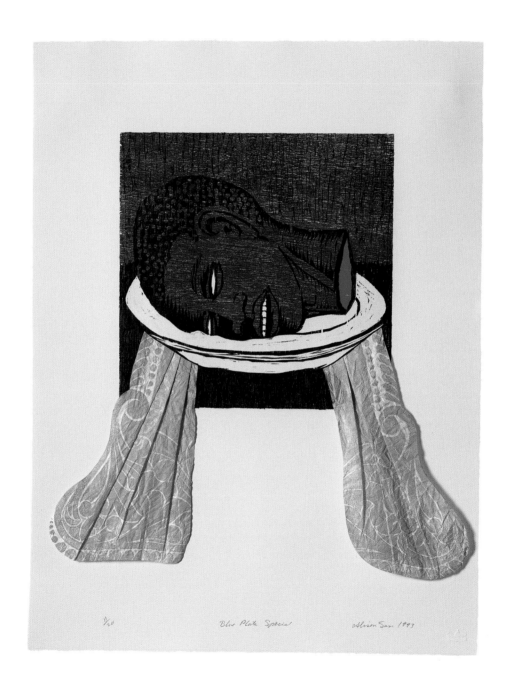

Figure 30:

Alison Saar, **Blue Plate Special,** *1993*

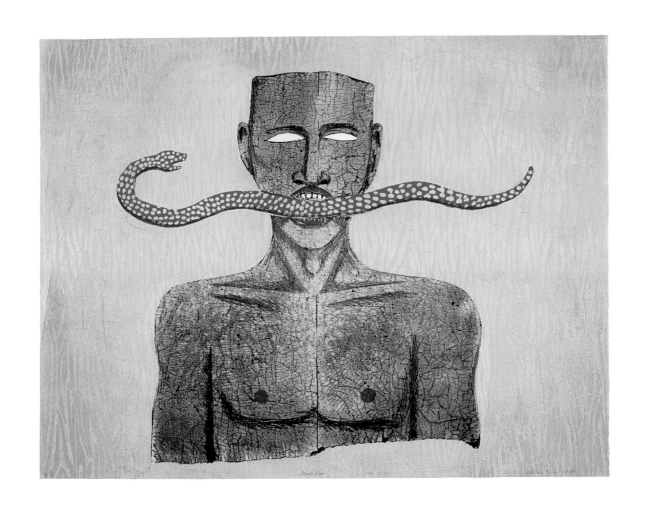

Bedia's native Cuba have provided these artists with powerful, and varied, visual vocabularies.

Gustavo Pérez Firmat, writing in the catalogue for the exhibition *José Bedia: De Donde Vengo*, explains Cuban society as an *ajiaco*, a stew of disparate parts that forms a whole without sacrificing the individual characters of its components.[66] To a large extent, Cuba is a deracinated culture, where people are united by belief systems rather than skin color. José Bedia's art draws upon Native American, African, Caribbean, and diaspora Cuban traditions, all of which play a role in the artist's life. As a practitioner of *palo monte*, a religion that originated in Africa, Bedia melds, in art and life, a keen understanding of trans-cultural mythology.[67] The artist has cited a belief in supernatural forces common to many cultures as a touchstone in his evolving artistic explorations.[68]

Bedia emigrated to the United States, by way of Mexico, in 1993. Now settled in Miami, he is among the leading artists of the Cuban diaspora, maintaining a connection with his artistic roots while in exile. His art, which employs drawing, installation, and found objects, was first seen by Pat Nick at The Museum of Modern Art during the exhibition *Latin American Artists of the Twentieth Century* in 1992. The strong graphic nature of Bedia's work, coupled with Nick's interest in Cuban art, resulted in an invitation to the Press in 1994.[69]

Bedia had made several prints, which were never editioned, during his three years in Mexico.[70] Although he only spent a week on Vinalhaven, the artist's output was prodigious: four editions and a series of monotypes. One of the most complex pieces to come out of his stay, *Jibaro* (1994) [Figure 32], uses a sequential method of storytelling that has its visual roots in ancient wall paintings and American comic strips. Bedia's distinctive figures are laid out in a grid of contrasting chine collé backgrounds, printed with a pattern that simulates the bark-textured *amate* paper the artist often uses in his large-scale drawings. The story relates the fortunes of man and animal, who, according to

Native American mythology, once lived together as a single race. In a series of numbered panels, man and animal are split, whereas in other examples of the artist's work, they merge. Both of these permutations refer to a belief in animal ancestors shared by a variety of Native American cultures.[71]

Bedia's drawing style was perfect for both lithography and soft-ground etching. While the former captured the energy of the artist's crayon marks, the latter translated these marks into rich three-dimensional lines and flat areas of texture. A case in point is *Ciclòn vs. Rayo* (1994) [Figure 33], which depicts a conflict between the wind and the sun. This composition was printed on three different chine collé papers, brilliant red Moriki, glowing yellow Moriki, and neutral value (cream colored) Okawara. These three papers bring a different energy to all three prints, while the combination of etched line and soft Asian paper presents a distinct visual tactility.

The Future of Traditional Printmaking

The last two decades have been marked by an explosion in technology that has dramatically changed the face of contemporary printmaking. While this trend has not halted the production of artistic statements in lithography, silkscreen, woodcut, and intaglio, it has changed the way these works look and communicate their message. The Vinalhaven Press has formed its identity during these vital years. Contemporary traditional print workshops like the Press have eschewed the slick look of technologically-based visual media and returned to the roots of graphic art, exploiting the sensuous and tactile properties of printmaking. This materialism, however, does not imply a lack of content. The works produced at the Press during the past twelve years have been marked by an equilibrium of subject and form, where neither concern dominates.

The Vinalhaven Press has been defined by an undercurrent of experimentation and calculated risk-taking in guiding artists through the process of

Figure 33:

José Bedia, **Ciclòn vs Rayo**, *1994*

printmaking. All of the artists discussed in this essay—be they experienced, or new to the process of printmaking—have benefited artistically from their association with the Press. Pat Nick and her staff encouraged these artists to step outside their habitual methods of expression while remaining focused on preserving and updating the use of historical print media. By inviting a select group of artists who will continue to expand the conceptual and material boundaries of traditional printmaking, Pat Nick has devoted time and care to continuing the history of making art in print.

Aprile Gallant

1 See David P. Becker, "The Vinalhaven Experience," in this catalogue, p. 12.

2 See pp. 30-34.

3 My discussion of Charles Hewitt is indebted to a conversation with the artist, September 3 ,1996, as well as a conversation with Anthony Kirk, July 1996. All quotes not otherwise cited are taken from these conversations.

4 Peter Saul, "Artist's Statement," in *Peter Saul* [exh. cat.] (Aspen, CO: Aspen Art Museum, 1989), n.p. (p. 16).

5 Saul, "Artist's Statement" (p. 20).

6 For a discussion of these works, see Robert Storr, "Peter Saul: The Uses of Disenchantment," in *Peter Saul* [exh. cat.] (Aspen, CO: Aspen Art Museum, 1989), n.p. (pp. 5-6).

7 Peter Saul, "Saul on Saul," *Peter Saul* [exh. cat.] (DeKalb, IL: Swen Parson Gallery, Northern Illinois University, 1980), pp. 14-15.

8 Conversation with Patricia Nick, September 13, 1996.

9 Saul, "Artist's Statement" (p. 22).

10 Conversation with George Adams, September 10, 1996.

11 Saul, "Artist's Statement" (p. 21). The concept of the "Bizzaro" superhero—a clone with directly opposite characteristics of the original—first appeared in comic books during the early-to-mid-1960s. I am indebted to Alison Quaglia for introducing me to the phenomenon.

12 See Donna DeSalvo and Paul Schimmel, *Hand-Painted Pop: American Art in Transition, 1955-62* [exh. cat.] (Los Angeles and New York: The Museum of Contemporary Art, Los Angeles, in association with Rizzoli International Publications, 1993).

13 Poppy Gandler Orchier, "Introduction," in Susan Sheehan, et. al., *Robert Indiana Prints: A Catalogue Raisonné, 1951-1991* (New York: Susan Sheehan Gallery, 1991), p. 7.

14 Carl J. Weinhardt, Jr., *Robert Indiana* (New York: Harry N. Abrams, Inc., 1990), p. 58.

15 William Katz, "Polychrome Polygonals: Robert Indiana's New American Geometry," in *Robert Indiana* [exh. cat.] (Austin: The University of Texas at Austin, 1977), p. 21.

16 Conversation with Patricia Nick, September 13, 1996.

17 Indiana's first project at the Press was a collaboration with the painter Carolyn Brady. *Erosia I* and *Erosia II* were printed during the summer of 1985 and featured Indiana's famous "LOVE" with monotype and lithograph (respectively) flowers by Brady. See Sheehan, p. 76.

18 These words first appeared in Indiana's painting in 1963. The words "EAT" and "DIE" refer to the death of the artist's mother, Carmen, whose last word was "eat."

19 Susan Ryan, "Vinalhaven Suite: An Artist is an Artist," *Artists in Maine* (Fall/Winter 1986), p. 33.

20 Weinhardt, p. 117.

21 Ryan, p. 34.

22 Ryan, p. 34.

23 Conversation with Robert Indiana, September 15, 1996.

24 Robert Cumming, "Artist's Statement," in Andrew Stevens, *Visions and Revisions: Robert Cumming's Works on Paper* [exh. cat.] (Madison, WI: Elvehjem Museum of Art, University of Wisconsin-Madison, 1991), p. 8.

25 Hugh M. Davies and Lynda Forsha, "A Conversation with Robert Cumming," in *Robert Cumming: Cone of Vision* [exh. cat.] (San Diego, CA: Museum of Contemporary Art, San Diego, 1993), p. 21.

26 Belinda Rathbone, "Robert Cumming: An Update," *Print Collector's Newsletter* (19, no. 5, November-December 1988), p. 172.

27 Conversation with Patricia Nick, September 13, 1996.

28 Robert Cumming, *Equilibrium and the Rotary Disc* (Providence, RI: Diana's Bimonthly Press, 1980), n.p. (p. 2).

29 Davies and Forsha, p. 28.

30 Cumming, "Artist's Statement," p. 8.

31 Becker, p. 17.

32 I am indebted to David Becker for this interpretation of Cumming's imagery (conversation with David Becker, September 24, 1996).

33 For a succinct overview of Chin's work, see John Beardsly, "Mel Chin," in *Visions of America: Landscape as Metaphor in the Late Twentieth Century* [exh. cat.] (Denver, CO: Denver Art Museum, 1994), pp. 118-124.

34 Ned Rifkin, *Directions: Mel Chin* [exh. cat.] (Washington D.C.: Hirshhorn Museum and Sculpture Garden, 1989), n.p. (p. 2).

35 Beardsly, p. 119.

36 Dick Davis, "Introduction," in Farid un-Din Attar, *The Conference of the Birds*, translated by Afkham Darbandi (New York: Viking Penguin, 1984), pp. 15-16.

37 Davis, p. 11.

38 Beardsly, p. 121.

39 For a full explanation of Chin's sources for *Revival Field*, see Thomas McEvilley, "Explicating Exfoliation in the Work of Mel Chin" in *Soil and Sky: Mel Chin* [exh. cat.] (Philadelphia: The Fabric Workshop, 1992), pp. 13-14.

40 The installation *State of Heaven* consists of a Turkish carpet, woven by Kurdish weavers, which depicts a map of clouds over Southern Iraq. The carpet will be undone and rewoven to record fluctuations in the ozone layer. For more information, and an excellent essay on Chin's work, see McEvilley, pp. 9-31. Also see Beardsly, p. 123. *In the Name of the Place* in-

volved the design of evocative props and sets which appeared on a popular television series. This project was set in motion by the exhibition *Uncommon Sense*, organized by the Museum of Contemporary Art, Los Angeles (March 16-July 6, 1997). See the project website and exhibition catalogue for more information.

41 Conversation with Patricia Nick, September 13, 1996.

42 Joshua Dector, "Komar & Melamid: Perennial Tourists in an Adopted Land," *Flash Art* 148 (October 1989), pp. 126-127.

43 Susan Ryan, interview with the artists in "Vinalhaven Suite: Tolstoy and Fish," *Artists in Maine* (Fall/Winter 1986), p. 27.

44 The text of the brochure reads: "The universal taste **Sears** produces exemplifies the contemporary American esthetic for **heavy duty beauty**. Through continued research and understanding of the interior and exterior environment of contemporary Americans, **Sears** has moved from **solid state** to **heavy duty** in just a few short years. It is no accident that **Kenmore** and **Craftsman** and other heavy duty **Sears** brands are what has made **Sears** the most universal power in American life. . . and through this power moves an esthetic of heaviness that has become the **pride of Sears****heavy duty plus**. And with our own pride, we have developed these exquisite woodblock prints, hand cut from genuine plywood in four exotic surfaces, as the true essence of Sears heaviness. They have been published by the Vinalhaven Press and printed there by John C. Erickson who we wish to thank for suggesting this catalogue."

45 See Richard Vine, "Numbers Racket," *Art in America* 82 (October 1994), pp. 116-119.

46 See *Robert Morris: The Mind/Body Problem* [exh. cat.] (New York: Solomon R. Guggenheim Museum, 1994).

47 Conversation with Patricia Nick, September 13, 1996.

48 Terrie Sultan, *Inability to Endure or Deny the World: Representation and Text in the Work of Robert Morris* [exh. cat.] (Washington, D.C.: The Corcoran Gallery of Art, 1990), pp. 15-16.

49 For an insightful discussion of Morris's quotation of the work of other artists, see David Antin, "Have Mind, Will Travel," in *Robert Morris: The Mind/Body Problem*, pp. 34-50.

50 For a complete discussion of Goya's "black" paintings, see Priscilla E. Muller, *Goya's "Black" Paintings: Truth and Reason in Light and Liberty* (New York: The Hispanic Society of America, 1984). For information on Goya's print series, see Eleanor Sayres, *The Changing Image: Prints by Francisco Goya* (Boston: Museum of Fine Arts, Boston, 1974).

51 See Sultan, pp. 21-22.

52 Conversation with Patricia Nick, September 13, 1996.

53 Yevgeni Barabanov, "The World as a Book," in *Grisha Bruskin: Paintings and Sculpture* [exh. cat.] (New York: Marlborough Gallery, Inc., 1990, pp. 2-5), p. 2.

54 Grisha Bruskin [written statement], in *Grisha Bruskin: Paintings and Sculpture* [exh. cat.](New York: Marlborough Gallery, Inc., 1990), p. 35.

55 Bruskin, p. 35.

56 Conversation with Patricia Nick, September 13, 1996.

57 Barbara Fisher, *Alain Paiement: Amphitheatres* (Montreal: The Power Plant, 1989), p. 3.

58 Fisher, p. 9. My overall discussion of Paiement's work is indebted to Fisher's insightful essay.

59 This is one of my own fascinations with multiples—that they can lead different "lives" at the same time. Each print in an edition, as Kathan Brown has noted (*Ink, Paper, Metal, Wood: Painters and Sculptors at Crown Point Press* [San Francisco: Chronicle Books, 1996], p. 16), is not a "copy," it is a work that carries the same visual information as others in the edition. The varied contexts allowed by multiples only widens the field of viewers who can interpret and appreciate the work.

60 Letter from Alain Paiement to the author, May 28, 1996. Paiement's new editions will be produced in Quebec in the winter of 1996-1997.

61 Quote from the artist in Chiori Santiago, "Secrets, Dialogues, Revelations: The Art of Betye and Alison Saar," *The Museum of California* (Summer 1990), p. 12.

62 Sidney Lawrence, *Directions: Alison Saar* [exh. cat.] (Washington D.C.: Hirshhorn Museum and Sculpture Garden, 1993), n.p. (p. 1.)

63 Conversation with Patricia Nick, September 13, 1996.

64 Quote from the artist in Jon Etra, "Family Ties," *Artnews* 90 (May 1991), p. 128.

65 Judith Bettelheim, "His Essentialism," in *José Bedia: Mi Essencialismo* (Dublin, Ireland: The Douglas Hyde Gallery, 1996), p. 3.

66 Gustavo Pérez Firmat, "The Art of Cuban Cooking," in *José Bedia: De Donde Vengo* [exh. cat. by Melissa Feldman] (Philadelphia: Institute of Contemporary Art, University of Pennsylvania, 1994), pp. 4, 6.

67 Bettelheim, p. 5.

68 Melissa Feldman, "Speaking in Tongues: The Work of José Bedia," in *José Bedia: De Donde Vengo*, p. 20.

69 Conversation with Patricia Nick, September 13, 1996.

70 Conversation with George Adams, September 10, 1996.

71 Feldman, p. 22.

Chronology of the Vinalhaven Press

Master printer:

A master printer is responsible for artist collaboration, development, proofing, and editioning of graphic works. Anyone designated as a master printer has reached the top of the profession.

Printer:

At Vinalhaven, printers assist with editioning. If an apprentice has participated in the editioning of an artist's work, he or she is cross-referenced as a printer for that project.

Year	Artist	Master Printer	Printer
1985			
	Peter Bodnar	William Haberman	
	Mel Bochner	Kathleen Caraccio Maurice Payne	Orlando Condeso
	Carolyn Brady	John C. Erickson Maurice Payne	Michelle French
	Louisa Chase	Orlando Condeso John C. Erickson	Susan Volker
	Jonathan Imber	Kathleen Caraccio John C. Erickson	Michelle French
	Robert Indiana	John C. Erickson	Michelle French
	Joan Thorne	Lynne Allen John C. Erickson Maurice Payne	Michelle French
1986			
	John Beerman	Sylvia Roth	Johanna Hesse
	Susan Crile	Orlando Condeso	Susan Volker
	Charles Hewitt	Anthony Kirk	Marie Arcand George Bartko Randy Hemminghaus
	Robert Indiana	Orlando Condeso Anthony Kirk	Susan Volker
	Kingsley Parker	Orlando Condeso	
	Komar & Melamid	Julio Juristo	Barbara McGill Balfour Randy Hemminghaus
	Robert Zakanitch	Julio Juristo	Barbara McGill Balfour Alan Flint Randy Hemminghaus

Year	Artist	Master Printer	Printer
1987			
	John Beerman	John C. Erickson	
	Susan Crile	Orlando Condeso	
	Robert Cumming	John C. Erickson	
	Patrick Dunfey	John C. Erickson	
	Aaron Fink	Frank Akers Randy Hemminghaus	
	Charles Hewitt	Randy Hemminghaus	Barbara McGill Balfour
	Dennis Kardon	Orlando Condeso	Chris Clark Susan Volker
	Kingsley Parker	Orlando Condeso	
1988			
	Robert Cumming	John C. Erickson	Robert MacDonald
	Leon Golub	Barbara McGill Balfour Randy Hemminghaus	
	Charles Hewitt	Randy Hemminghaus	Susan Hover
	Robert Morris	Orlando Condeso	Susan Volker
1989			
	Susan Crile	John C. Erickson	Celeste Bard Andrew Bloom Katherine Kreisher Monica Torrebiarte Jessica Rice
	Robert Cumming	John C. Erickson	Robert MacDonald
	Charles Hewitt	Randy Hemminghaus	Paul Stilpass
	Robert Morris	Orlando Condeso	
	Alain Paiement	Randy Hemminghaus	Celeste Bard Jeanne Bard
1990			
	Robert Cumming	Brenda Zlamany	
	Charles Hewitt	Randy Hemminghaus	
	Robert Indiana	John C. Erickson	Barbara McGill Balfour Herbert C. Fox Randy Hemminghaus
	Yvonne Jacquette	John C. Erickson	
	Komar & Melamid	John C. Erickson	Barbara McGill Balfour Randy Hemminghaus
1991			
	Robert Cumming	Brenda Zlamany	Peter Suchecki Brendan O'Malley Michael Hairston

Year	Artist	Master Printer	Printer
1991 (cont.)			
	Charles Hewitt	Randy Hemminghaus	
	Robert Indiana	James Davies Cambronne	
	Yvonne Jacquette	John C. Erickson	
1992			
	Grisha Bruskin	Randy Hemminghaus	Amy Bergin Jonathan Higgins Wendy Newman
	Charles Hewitt	Randy Hemminghaus	
	Robert Indiana	Randy Hemminghaus Jonathan Higgins	
1993			
	Charles Hewitt	Randy Hemminghaus	
	Alison Saar	Randy Hemminghaus Jonathan Higgins	
1994			
	José Bedia	Randy Hemminghaus	Kathleen Beckert Jonathan Higgins Scott Smith
	Alison Saar	Jonathan Higgins	Kathleen Beckert Chris Clark Karoline Schleh Scott Smith
1995			
	Peter Saul	Randy Hemminghaus Jonathan Higgins	
1996			
	Mel Chin	Randy Hemminghaus Jonathan Higgins	

Vinalhaven Press Apprentices

1985 - 1996

Vinalhaven apprentices serve as shop assistants, working with the master printers in the development and proofing of print projects. Apprentices also provide assistance with maintenance, inventory, and record keeping.

Tim Amory	1988, 1989
Gabrielle Apuzzo	1992
Marie Arcand	1986
Barbara McGill Balfour	1986, 1987
Celeste Bard	1988, 1989
Jeanne Bard	1988
Tad Beck	1990
Kathleen Beckert	1994
Amy Bergin	1992
David Blaustein	1989
Andrew Bloom	1988, 1989
Russell Calabrese	1990
Mary Casandra Chen	1990
Chris Clark	1987, 1989, 1990, 1993, 1994, 1995
Amy Lou Cohen	1990
Angela Cooper	1992
Ann Ropp Curtis	1989
Thorston Dimmerline	1993
Michael Eder	1988, 1989
Amy Evans	1992
Benicia Gantner	1993
Larry Giacoletti	1995
Elizabeth Hagy	1989
Nicole Hahn	1995
Michael Hairston	1991
Steve Hanson	1992
Wendy Harrison	1989
Randy Hemminghaus	1986, 1987
Charles Harvey	1990
Richard Harvey	1989
Donna Hodkins	1988
Susan Hover	1988
Kent Kapplinger	1992
Ron Kim	1987
Katharine Kreisher	1988, 1989
Rebecca Lax	1988
Kathryn Lyness	1989
Rita MacDonald	1990
Robert MacDonald	1988, 1989
Holly Maitland	1987
Steven Miller	1988
David Mohallatee	1991
Charles Morris	1990
Wendy Newman	1992
Brendan O'Malley	1991
Gould Porter	1995
Diana Quinby	1990
Jessica Rice	1989
Christopher Roscoe	1990
Susan Rostow	1990
Matthew Rousey	1989
Karoline Schleh	1994
Scott Smith	1994
Tom Staley	1993
Paul Stillpass	1989
Peter C. Suchecki	1991
Nina Eastman Sylvester	1988
Craig Taylor	1995
Deborah Tint	1990
Monica Torrebiarte	1991
Laura Watt	1988
Jeffrey Weber	1991
Terri Weisman	1990
Lisa Westerfelt	1990
William Zindel	1988

José Bedia

Born in Havana, Cuba, 1959
Lives and works in Miami, FL
Educated at School of San Alejandro, Havana
(1976), and The Superior Institute of Art, Havana
(1981)

José Bedia with Hombre de Perro, *1994*
Photograph by Lenore Bedia

Selected One-Person Exhibitions
"Mi Essencialismo," Hyde Gallery, Trinity College,
 Dublin. Traveled to Porin Tadmuseo, Pori,
 Finland; George Adams Gallery, New York, NY,
 1996
"José Bedia: De Donde Vengo," Institute of
 Contemporary Art, University of Pennsylvania,
 Philadelphia, PA. Traveled to the Center for the
 Fine Arts, Miami, FL; Museum of Contemporary
 Art, San Diego, CA, 1994-1995
Sao Paulo Biennal, Sao Paulo, Brazil, 1994
"Brevisima Relacion de la Destruccion de las
 Indias," Museo de Arte Contemporaneo Carillo
 Gil, Mexico City, D.F. Selected works traveled to
 Frumkin/Adams Gallery, New York, NY, 1992
"Los Presagios," IV Bienal de la Havana, Cuba,
 1991

Selected Group Exhibitions
"Cartographies," Winnipeg Art Gallery, Manitoba,
 Canada. Traveled to Biblioteca Louis Angel,
 Arango, Bogota; Museum of Visual Arts, Caracas,
 Venezuela; National Gallery of Canada, Ottawa;
 The Bronx Museum of the Arts, Bronx, NY, 1993-
 1994
"Latin American Artists of the Twentieth Century,"
 The Museum of Modern Art, New York, NY.
 Traveled to the Estacion Plaza de Armas, Seville,
 Spain; Hotel des Arts, Paris, France (contempo-
 rary section); Museum Ludwig, Cologne, Ger-
 many, 1992-1993
"Mito y Magia en America: Los Ochenta," Museo de
 Arte Contemporaneo de Monterrey (MARCO)
 Monterrey, N.L., Mexico, 1991
"Kuba O.K.," Stafische Kunsthalle, Dusseldorf,
Germany, 1990

John Beerman

Born in Greensboro, NC, 1958
Lives and works in South Nyack, NY
Educated at Rhode Island School of Design,
Providence, RI (B.F.A., 1982) and Skowhegan
School of Painting and Sculpture, Skowhegan, ME
(1981)

John Beerman, 1985

Selected One-Person Exhibitions
Somerhill Gallery, Chapel Hill, NC, 1996
David Beitzel Gallery, New York, NY, 1995
Somerhill Gallery. Traveled to St. Johns Museum,
 Wilmington, DE; Greenville Museum of Art,
 Greenville, NC, 1994
"Finding the Forgotten," North Carolina Museum of
 Art, Raleigh, NC, 1991

Selected Group Exhibitions
"Printmaking in America, Collaborative Prints and
 Presses, 1960-1990," Mary and Leigh Block
 Gallery, Northwestern University, Evanston, IL.
 Traveled to The Jane Voorhees Zimmerli Art
 Museum, Rutgers University, New Brunswick, NJ;
 Museum of Fine Art, Houston, TX; and National
 Museum of American Art, Smithsonian Institution,
 Washington, DC, 1995
"Into the Nineties: Prints from the Tamarind
 Institute," Weatherspoon Art Gallery, Greensboro,
 NC, 1995
"Seeing the Forest Through the Trees," Contempo-
 rary Arts Museum, Houston, TX, 1993
"International Biennial of Graphic Art," Ljubljana,
 Yugoslavia, 1989
"The 1980s: A New Generation," The Metropolitan
 Museum of Art, New York, NY, 1988

Selected Honors and Awards
Subscription Prize, The Jane Voorhees Zimmerli Art
 Museum, Rutgers University, 1986
Visual Artist Fellowship in Painting, Yaddo,
 Saratoga Springs, NY, 1984

Mel Bochner

Born in Pittsburgh, PA, 1940
Lives and works in New York, NY
Educated at Carnegie Institute of Technology,
Pittsburgh, PA (B.F.A., 1962)

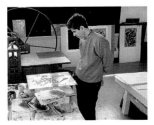

Mel Bochner,
1985
Photograph by Alice Bissle

Selected One-Person Exhibitions
"Mel Bochner: Thought Made Visible, 1966-1973,"
 Yale University Art Gallery, New Haven, CT, 1995
Sonnebend Gallery, New York, NY, 1993
The Baltimore Museum of Art, Baltimore, MD,
 1989, 1976
Kunstmuseum Luzern, Switzerland, 1986
Carnegie-Mellon University Art Gallery, Pittsburgh,
 PA, 1985
The Museum of Modern Art, New York, NY, 1971

Selected Group Exhibitions
"On Certainty," Sonnebend Gallery, New York, NY,
 1992
"L'art Conceptuel, Une Perspective," Musée d'Art
 Moderne de la Ville de Paris, Paris, France, 1989
"Minimalism to Expressionism," Whitney Museum
 of American Art, New York, NY, 1983
"Print Sequence," The Museum of Modern Art, New
 York, NY, 1975
"New American Graphic Art," Fogg Art Museum,
 Harvard University, Cambridge, MA, 1973
"Using Walls," The Jewish Museum, New York, NY,
 1970

Selected Honors and Awards
Artist in Residence, American Academy in Rome,
 1991
Award in Art, American Academy and Institute of
 Arts and Letters, 1990
National Endowment for the Arts Fellowship,
 1982, 1974
John Simon Guggenheim Memorial Fellowship,
 1972

Peter Bodnar

Born in Andrejova, Czechoslovakia, 1928
Lives and works in Urbana, IL, and Vinalhaven, ME
Educated at Flint Institute of Art, Flint, MI, Western
Michigan University, Kalamazoo, MI (B.A., 1951)
and Michigan State University, East Lansing, MI
(M.F.A., 1956)

Selected One-Person Exhibitions
Levis Faculty Center, University of Illinois, Urbana,
 IL, 1982
Northern Montana University, Havre, MT, 1981
University of Southern California, Los Angeles, CA,
 1977
Newport Harbor Museum, Newport Beach, CA,
 1974
Southern Methodist University, Dallas, TX, 1971

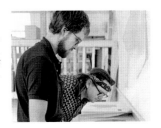

left to right:
William Haberman
and Peter Bodnar,
1985
Photograph by Alice Bissle

Selected Group Exhibitions
Illinois Painters' Invitational, Western Illinois
 University, Macomb, IL, 1992
Kunsthalle, Bremen, Germany, 1990
Rockford Art Museum, Rockford, IL, 1988
Cranbrook Academy of Art, Bloomfield Hills, MI,
 1987
"The Contemporary Arts Center Biennial," Contem-
 porary Arts Center, Cincinnati, OH, 1986

Selected Honors and Awards
Fellow, Center for Advanced Study, University of
 Illinois, 1982-1983, 1967-1968
Tamarind Lithography Grant, 1982, 1976,
 1975, 1964
National Endowment for the Arts Fellowship, 1975-
 1976

Carolyn Brady

Born in Chickasha, OK, 1937
Lives and works in Pittsburgh, PA
Educated at Oklahoma State University, Stillwater,
OK (1955-1958) and University of Oklahoma at
Norman (B.F.A., 1959; M.F.A., 1961)

Selected One-Person Exhibitions
Nancy Hoffman Gallery, New York, NY, 1995, 1993,
 1991, 1989, 1987, 1985, 1983, 1980, 1977
"Carolyn Brady Watercolors," The Philbrook
 Museum of Art, Tulsa, OK. Traveled to Wichita
 Art Museum, Wichita, KN; University of Okla-
 homa Museum of Art, Norman, OK; Schick Art
 Gallery, Skidmore College, Saratoga Springs, NY,
 1989-1990
William A. Farnsworth Library and Art Museum,
 Rockland, ME, 1987
Mint Museum of Art, Charlotte, NC, 1982
Art Gallery, University of Rhode Island, Kingston,
 RI, 1977

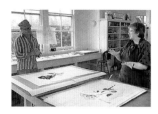

Robert Indiana and Carolyn Brady, 1985

Photograph by Alice Bissle

Selected Group Exhibitions

"Women in Print: Prints from 3M by Contemporary Women Printmakers," The Concourse Gallery, 3M Center, St. Paul, MN, 1995

"American Realism & Figurative Art: 1955-1990," The Miyagi Museum of Art, Miyagi, Japan. Traveled to Sogo Museum of Art, Yokohama; Tokushima Modern Art Museum, Tokushima; Museum of Modern Art, Shiba Otsu; Kochi Prefectural Museum of Folk Art, Kochi, 1991-1992

"American Traditions in Watercolor," The Worcester Art Museum, Worcester, MA. Traveled to Minneapolis Institute of Art, Minneapolis, MN; National Museum of American Art, Smithsonian Institution, Washington, DC, 1987

"Contemporary American Realism Since 1960," Pennsylvania Academy of the Fine Arts, Philadelphia, PA. Traveled to Oakland Museum of Art, Oakland, CA; Virginia Museum of Fine Arts, Richmond, VA; Kunsthalle, Nuremberg, Germany, 1981-1983

Grisha Bruskin

Born in Moscow, U.S.S.R., 1945
Lives and works in New York, NY
Educated at Moscow Textile Institute, Moscow (1968)

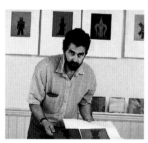

Grisha Bruskin checking proofs for Lexica, 1992

Selected One-Person Exhibitions

Marlborough Gallery, New York, NY, 1994, 1990

"General Instruction," The State Pushkin Museum of Fine Arts, Moscow. Traveled to St. Petersburg, 1993

"Grisha Bruskin: Paintings and Sculpture," Hokin Gallery, Palm Beach, FL, 1991

"Grisha Bruskin," Central House of Workers in the Arts, Moscow, 1984

"Grisha Bruskin," Vilnius, Lithuania, 1983

House of Artists, Moscow, 1976

Selected Group Exhibitions

"Post-Modernism and Tradition," State Tretyakov Gallery, Moscow, 1993

"Drawing the Line Against AIDS," Venice Biennale, Venice, Italy. Traveled to Guggenheim Museum Soho, New York, NY, 1993

"Ost-Kunst, West-Kunst," Ludwig Forum for International Art, Aachen, Germany, 1991

"100 Years of Russian Art, 1889-1989 from Private Collections in the U.S.S.R.," Barbican Art Gallery, London, England. Traveled to Museum of Modern Art, Oxford, England; Soviet Cultural Foundation, Moscow, 1989

"Olympiad of Art," National Museum of Contemporary Art, Seoul, Korea, 1988

"Seventh Exhibition of Young Artists of Moscow," House of Artists, Moscow, 1966

Louisa Chase

Born in Panama City, Panama, 1951
Lives and works in New York, NY
Educated at Syracuse University (B.F.A., 1973) and Yale University (M.F.A., 1975)

John C. Erickson and Louisa Chase, 1985

Photograph by Alice Bissle

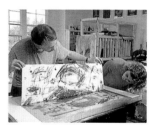

Selected One-Person Exhibitions

Brooke Alexander, New York, NY, 1991, 1989

Tokyo Ginza Art Center Hall, Tokyo, Japan. Traveled to Kyoto Art Center Hall, Kyoto; Kanazawa Art Center Hall, Kanazawa, 1991

Robert Miller Gallery, New York, NY, 1986, 1984, 1982, 1981

"Louisa Chase, Recent Prints and Drawings," Alice Simsar Gallery, Ann Arbor, MI, 1985

"Currents: Louisa Chase," The Institute of Contemporary Art, Boston, MA, 1984

Artists Space, New York, NY, 1975

Selected Group Exhibitions

"Painters on Press: Recent Abstractions," Madison Art Center, Madison, WI, 1992

"Making Their Mark: Women Artists Move into the Mainstream, 1979-1985," Cincinnati Art Museum, Cincinnati, OH. Traveled to New Orleans Museum of Art, New Orleans, LA; Denver Art Museum, Denver, CO; Pennsylvania Academy of Fine Arts, Philadelphia, PA, 1989

"The 1980s: A New Generation of American Painters and Sculptors," Metropolitan Museum of Art, New York, NY, 1988

"A Graphic Muse: Prints by Contemporary American Women," Mount Holyoke College Museum of Art, South Hadley, MA. Traveled to Yale University Art Gallery, New Haven, CT; Santa Barbara Museum of Art, Santa Barbara, CA; Virginia Museum of Fine Arts, Richmond, VA; The Nelson-Atkins Museum of Art, Kansas City, MO, 1987

"Content: A Contemporary Focus, 1974-84," Hirshhorn Museum and Sculpture Garden, Washington, DC, 1984

"Prints from Blocks: Gauguin to Now," The Museum of Modern Art, New York, NY, 1983

Mel Chin

Born in Houston, TX, 1951
Lives and works in Athens, GA, and New York, NY
Educated at Peabody College, Nashville, TN (B.A., 1975)

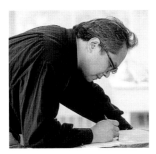

Mel Chin working on the lithographic stone for Imperfect Pearls in the Ether of Eternal Labor, *1996*

Photograph by Christopher Ayers

Selected One-Person Exhibitions
"Inescapable Histories," Exhibits USA, traveling exhibition, 1997-1999

"Soil and Sky," The Fabric Workshop and Swarthmore College, Philadelphia, PA, 1992

"Mel Chin," The Menil Collection, Houston, TX, 1991

"Viewpoints: Mel Chin," Walker Art Center, Minneapolis, MN, 1990

"Directions: Mel Chin," Hirshhorn Museum and Sculpture Garden, Washington, DC, 1989

Selected Group Exhibitions
"Fragile Ecologies," Queens Museum of Art, Flushing, NY. Traveled to Whatcom Museum of History and Art, Bellingham, WA; San Jose Museum of Art, San Jose, CA; Madison Art Center, Madison, WI; DeCordova Museum and Sculpture Park, Lincoln, MA; Center for the Fine Arts, Miami, FL, 1992-1994

"Allocations: Art for a Natural and Artificial Environment," Floriadepark, Zoetermeer, the Netherlands, 1992

"Diverse Representations," Morris Museum, Morristown, NJ, 1990

"International Memorial Arts Festival: China, June 4," Institute for Contemporary Art (P.S.1), Long Island City, NY, 1990

"The Texas Landscape, 1900-1986," Museum of Fine Arts, Houston, TX, 1986

Selected Projects and Installations
"Revival Field," Palmerton, PA (1993); Floriadepark, Zoetermeer, the Netherlands (1992); Pig's Eye Landfill, St. Paul, MN (1991)

"Conditions for Memory," Central Park, New York, NY, 1989

"The Edge That Cuts Also Instructs," Graham Gallery, Houston, TX, and Frumkin/Adams Gallery, New York, NY, 1988

"The Manila Palm," Contemporary Arts Museum, Houston, TX, 1978

Selected Honors and Awards
Cal Arts Alpert Award in the Visual Arts, 1995
Penny McCall Foundation Award, 1991
National Endowment for the Arts, Artist's Projects/New Forms, 1990-1991
Louis Comfort Tiffany Foundation Grant, 1989
Pollock/Krasner Foundation Fellowship, 1989
National Endowment for the Arts Fellowship, 1988

Susan Crile

Born in Cleveland, OH, 1942
Lives and works in New York, NY
Educated at Bennington College, Bennington, VT (B.A., 1965), and Hunter College, New York, NY (1971-1972)

Susan Crile reviewing proofs of Thoroughfare, *1986.*

Selected One-Person Exhibitions
"The Fires of War," National Council for Culture, Art and Letters, Kuwait City, State of Kuwait. Traveled to The Herbert Johnson Museum, Cornell University, Ithaca, NY; Middlebury College Museum of Art, Middlebury, VT; The Federal Reserve Board, Washington, DC; Saint Louis Art Museum, St. Louis, MO; Sarah Campbell Blaffer Gallery, University of Houston, Houston, TX; University Art Museum, California State University, Long Beach, CA, 1995

James Graham & Sons, New York, NY, 1995

Harvard University Graduate School of Design, Cambridge, MA, 1994

Graham Modern Gallery, New York, NY, 1990, 1988, 1987, 1985

Cleveland Center for Contemporary Art, Cleveland, OH, 1984

Selected Group Exhibitions
"Reinterpreting Landscape," Maier Museum of Art, Lynchberg, VA, 1996

"Art on Paper," Weatherspoon Art Gallery, Greensboro, NC, 1995

"The Prints from the Joshua P. Smith Collection," The National Gallery, Washington, DC, 1990

"After Matisse," organized by Independent Curators, Inc. Traveled to Queens Museum, Flushing, NY; Chrysler Museum, Norfolk, VA; Portland Museum of Art, Portland, ME; Bass Museum, Miami, FL; Phillips Collection, Washington, DC; Danforth Art Institute, Danforth, OH; Worcester Art Museum, Worcester, MA, 1986

"The American Artist as Printmaker," The Brooklyn Museum, Brooklyn, NY, 1983

Selected Awards and Honors
Artist in Residence, American Academy in Rome, 1990

National Endowment for the Arts Fellowship, 1989-1990, 1982

MacDowell Colony, Peterborough, NH, 1972

Robert Cumming

Born in Worcester, MA, 1943
Lives and works in West Suffield, CT
Educated at Massachusetts College of Art, Boston, MA (B.F.A., 1965), and The University of Illinois, Champaign, IL (M.F.A., 1967)

Robert Cumming working on monotype Islands: Penobscot Bay, *1987*

Selected One-Person Exhibitions
"Robert Cumming: Photographic Works, 1969-1980," Fonds Regional d'Art Contemporain, Limoges, France, 1994

"Robert Cumming: Cone of Vision, 25 Year Retrospective," Museum of Contemporary Art, San Diego, CA. Traveled to Museum of Fine Arts, Boston, MA; Contemporary Arts Museum, Houston, TX; The Contemporary Museum, Honolulu, HI, 1993-1994

"Directions: Robert Cumming Intuitive Inventions," Hirshhorn Museum and Sculpture Garden, Washington, DC, 1988

"Mechanical Illusions," Whitney Museum of American Art, New York, NY, 1986

Castelli Uptown, New York, NY, 1985, 1984, 1982

Selected Group Exhibitions
"Word as Image: American Art 1960-1990," Milwaukee Art Museum, Milwaukee, WI, 1990

"Projects and Portfolios, 25th National Print Exhibition," The Brooklyn Museum, Brooklyn, NY, 1989

"Image World: Art and Media Culture," Whitney Museum of American Art, 1989

"Fabricated to be Photographed," San Francisco Museum of Modern Art, CA, 1979

"Mirrors and Windows, American Photography since 1960," The Museum of Modern Art, New York, NY. Traveled to Cleveland Museum of Art, Cleveland, OH; Walker Art Center, Minneapolis, MN; J.B. Speed Art Museum, Louisville, KY; San Francisco Museum of Modern Art, San Francisco, CA; Krannert Art Museum, University of Illinois, Champaign, IL; Virginia Museum of Fine Arts, Richmond, VA; Milwaukee Art Center, Milwaukee, WI, 1978-1982

Selected Awards
Gottlieb Foundation Grant, 1995

Public Sculpture Commission, Lowell, MA, 1990

John Simon Guggenheim Memorial Fellowship, 1980-1981

National Endowment for the Arts Fellowship, 1979, 1975, 1972

Patrick Dunfey

Born in Exeter, NH, 1957
Lives and works in Hanover, NH
Educated in Rome, Italy (1980-81) and Rhode Island School of Design (B.F.A., 1981)

Patrick Dunfey working on Mexico, *1987*

Selected One-Person Exhibitions
Edward Thorp Gallery, New York, NY, 1993
Garner Tullis Workshop, New York, NY, 1989
Damon Brandt Gallery, New York, NY, 1987-1989
Pence Gallery, Santa Monica, CA, 1988
AVA Gallery, Hanover, NH, 1988, 1986

Selected Group Exhibitions
Edward Thorp Gallery, 1992-1993
Damon Brandt Gallery, 1990, 1989, 1986
Lang & O'Hara Gallery, New York, NY, 1989
"New Artists," Currier Gallery of Art, Manchester, NH, 1987
Concord College, Athens, WV, 1986
"Art and Architecture," Palazzo Cenci, Rome, Italy, 1980

Aaron Fink

Born in Boston, MA, 1955
Lives and works in Boston
Educated at Skowhegan School of Painting and
Sculpture (1976), Maryland Institute, College of Art
(B.F.A., 1977), and Yale University, School of Art
and Architecture (M.F.A., 1979)

left to right:
*Frank Akers and Aaron
Fink checking proofs for
Two Heads,
1987*

Selected One-Person Exhibitions
"Aaron Fink: Paintings, 1984-1995," Rockford Art
 Museum, Rockford, IL, 1995-1996
David Beitzel Gallery, 1995, 1993, 1990, 1988
Alpha Gallery, Boston, MA, 1995, 1989-1993, 1987,
 1985, 1983, 1981
Galerie Barbra Farber, Amsterdam, the Netherlands,
 1994, 1991, 1987, 1985, 1981
"Aaron Fink: Ten Years of Printmaking at the
 Center Street Studio," Center Street Studio,
 Boston, MA, 1994

Selected Group Exhibitions
"Narrative Expressions: Four Artists and the Print,"
 Jaffe-Friede and Strauss Galleries, Dartmouth
 College, Hanover, NH, 1994
"A Feast for the Eyes," Capitol Cities/ABC, orga-
 nized by The Museum of Modern Art, Art
 Advisory Service, 1992
"The Unique Print: The '70s into the '90s," Museum
 of Fine Arts, Boston, MA, 1990
"The Age of Pluralism," Centro di Cultura Ausoni,
 Rome, Italy, 1989
"Public and Private: American Prints Today," The
 Brooklyn Museum, Brooklyn, NY, 1986

Selected Honors and Awards
National Endowment for the Arts Fellowship, 1987,
 1982

Leon Golub

Born in Chicago, IL, 1922
Lives and works in New York, NY
Educated at University of Chicago (B.A., 1942), and
School of the Art Institute of Chicago (B.F.A., 1949;
M.F.A., 1950)

Selected One-Person Exhibitions
"Snake Eyes: The Sphinx and Other Enigmas:
 1952-56," Ronald Feldman Fine Art, New York,
 NY, 1996

"Violence Report: Prisoners," Kunsthalle Barmen,
 von der Heydt-Museum, Wuppertal, Germany.
 Traveled to Kunstverein Ulm, Ulmer Museum,
 Ulm, Germany, 1993
"Leon Golub Paintings 1987-92," Institute of
 Contemporary Art, Philadelphia, PA. Traveled to
 The Contemporary Museum, Honolulu, HI;
 Akron Art Museum, Akron, OH, 1992
"Worldwide," The Brooklyn Museum, Brooklyn,
 NY. Traveled to Dickinson College, Carlisle, PA;
 University of California, San Diego, CA;
 Chicago Cultural Center, Chicago, IL; Lehigh
 University, Bethlehem, PA, 1991
"Golub: Retrospective Exhibition," The New
 Museum of Contemporary Art, New York, NY.
 Traveled to La Jolla Museum of Contemporary
 Art, LaJolla, CA; Museum of Contemporary Art,
 Chicago, IL; The Montreal Museum of Fine Arts,
 Montreal, Canada; The Corcoran Gallery of Art,
 Washington, DC; The Museum of Fine Arts,
 Boston, MA, 1984

clockwise from left:
*Leon Golub, Charles
Hewitt, and Randy
Hemminghaus,
1988*

Selected Group Exhibitions
"Artists of Conscience," Alternative Museum, New
 York, NY, 1993
"Parallel Visions: Modern Artists & Outsider Art,"
 Los Angeles County Museum of Art, Los Angeles,
 CA. Traveled to Centro de Arte Reina Sofia,
 Madrid; Kunsthalle, Basel; Setagaya Art Museum,
 Tokyo, Japan, 1992
"16 Years of Social & Political Commentary,"
 Alternative Museum, 1991
"Goya A Beijing," Centre Internationnal D'Art
 Contemporain de Montréal, Montréal, Canada,
 1990
"Committed to Print," The Museum of Modern Art,
 New York, NY, 1988
"State of War: New European and American
 Painting," Seattle Art Museum, Seattle, WA, 1985

Selected Honors and Awards
Chicago Committee to Defend the Bill of Rights
 Award, 1989
Honorary Doctor of Fine Arts, School of the Art
 Institute of Chicago, 1982
American Academy of Arts and Letters, National
 Institute of Arts and Letters, 1973
John Simon Guggenheim Memorial Fellowship,
 1968
Tamarind Lithography Grant, 1965
Ford Foundation Grant, 1960

Charles Hewitt

Born in Lewiston, ME, 1946
Lives and works in New York, NY
Educated at Concord College, Athens, WV (B.A., 1968)

Charles Hewitt inking a plate for The Heartland, *1993*

Selected One-Person Exhibitions
June Fitzpatrick Gallery, Portland, ME, 1996, 1995
Jim Kempner Fine Arts, New York, NY, 1995
Kouros Gallery, New York, NY, 1994
Olin Arts Center, Bates College, Lewiston, ME, 1992
State University of New York, Binghamton, Binghamton, NY, 1982, 1975

Selected Group Exhibitions
"Forty Years of Maine Painting," Maine Coast Artists, Rockport, ME, 1990
Condeso/Lawler Gallery, New York, NY, 1989
"Contemporary Woodblock Prints," Jersey City Museum, Jersey City, NJ, 1989
"International Biennial of Graphic Art," Ljubljana, Yugoslavia, 1989
"Public & Private: American Prints Today," The Brooklyn Museum, Brooklyn, NY, 1986
Weatherspoon Art Gallery, Greensboro, NC, 1974

Selected Honors and Awards
New York State Council on the Arts, CAPS Grant, 1974

Jonathan Imber

Born in Baldwin, NY, 1950
Lives and works in Somerville, MA
Educated at Cornell University, Ithaca, NY (B.F.A., 1972), and Boston University, Boston, MA (M.F.A., 1977)

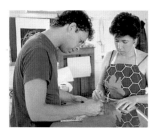

Jon Imber and Kathy Caraccio, 1985

Selected One-Person Exhibitions
Nielson Gallery, Boston, MA, 1996, 1995, 1993, 1992, 1989, 1986, 1984, 1982, 1981
"Jon Imber Drawings," Tabor Academy, Braitmayer Art Center, Marion, MA, 1995
"Survey of Paintings, 1978-1989," Fitchburg Art Museum, Fitchburg, MA. Traveled to Victoria Munroe Gallery, New York, NY, 1990
Victoria Munroe Gallery, 1987, 1985, 1984

Selected Group Exhibitions
"Inspired by Nature: A Contemporary View," Boston College Museum of Art, Boston, MA, 1995
"Landscape as Metaphor," Fitchburg Art Museum, Fitchburg, MA. Traveled to Newport Art Museum, Newport, RI, 1993
"Exquisite Corpse," The Drawing Center, New York, NY, 1993
"New England Impressions: The Art of Printmaking," Fitchburg Art Museum. Traveled to Galerie Kunst In Turm, Schwanenburg, Germany, 1988-1989
"Boston Baroque: Elements of Drama in Contemporary Art," DeCordova Museum and Sculpture Park, Lincoln, MA, 1987
"Fresh Images," Rose Art Museum, Brandeis University, Waltham, MA, 1978

Selected Honors and Awards
National Endowment for the Arts Fellowship, 1987
The Engelhard Award, Engelhard Foundation, Cambridge, MA, 1984
Massachusetts Artists Fellowship, Artists Foundation, Cambridge, MA, 1984

Robert Indiana

Born in New Castle, IN, 1928
Lives and works in Vinalhaven, ME
Educated at John Herron Art Institute (1945), Syracuse University (1947-1948), Skowhegan School of Painting and Sculpture (1953), Chicago Art Institute, Chicago, IL (B.F.A., 1954), Edinburgh College of Art (1953), University of London (1953)

Robert Indiana signing edition of Wall, *1990*

Selected One-Person Exhibitions
National Museum of American Art, Smithsonian Institution, Washington, DC, 1984
Indianapolis Museum of Art, IN, 1978
Gallery Denise Rene, New York, NY, 1975-1976, 1972

Institute of Contemporary Art, of the University of
Pennsylvania, Philadelphia, PA, 1968
Stable Gallery, New York, NY, 1966, 1964, 1962
Walker Art Center, Minneapolis, MN, 1963

Selected Group Exhibitions

"Dictated by Life: Marsden Hartley's German
Paintings and Robert Indiana's Hartley Elegies,"
Frederick R. Weisman Art Museum, University of
Minnesota, Minneapolis, MN. Traveled to Terra
Museum of American Art, Chicago, IL; The
Art Museum at Florida International University,
Miami, FL, 1995
"Art About Art," Whitney Museum of American Art,
New York, NY, 1978
"Thirty Years of American Printmaking," The
Brooklyn Museum, Brooklyn, NY, 1976
"Opening Exhibition," Hirshhorn Museum and
Sculpture Garden, Washington, DC, 1974
"The Artist as Adversary," The Museum of Modern
Art, New York, NY, 1971
"Word and Image," Solomon R. Guggenheim
Museum, New York, NY, 1965
"Painting and Sculpture of a Decade," Tate Gallery,
London; New York State Pavilion, New York
World's Fair, 1964
"The Art of Assemblage," The Museum of Modern
Art, New York, 1961

Selected Honors and Awards

Honorary Doctor of Fine Arts, Colby College,
Waterville, ME, 1981
Honorary Doctor of Fine Arts, The
University of Indiana, Bloomington, IN, 1977
Honorary Doctor of Fine Arts, Franklin
and Marshall College, Lancaster, PA, 1970

Yvonne Jacquette

Born in Pittsburgh, PA, 1934
Lives and works in New York, NY
Educated at Rhode Island School of Design,
Providence, RI (B.F.A., 1956)

left to right:
*David Becker, Yvonne
Jacquette, and
Patricia Nick,
1991*

Selected One-Person Exhibitions

"Aeriel Muse: The Art of Yvonne Jacquette," Iris
and B. Gerald Cantor Center for the Visual Arts,
Stanford University, Stanford, CA (in preparation)
"Yvonne Jacquette: Paintings and Pastels, 1992-
1994," Brooke Alexander, New York, NY, 1995

"Yvonne Jacquette: Frescoes, Monotypes, Pastels,
and Prints," Brooke Alexander Editions, New
York, NY, 1992
Yurakucho Seibu/Takanawa Art, Tokyo, Japan,
1985
"Currents 22: Yvonne Jaquette," St. Louis Art
Museum, St. Louise, MO, 1983
Brooke Alexander, 1988, 1986, 1983, 1982, 1981

Selected Group Exhibitions

"Women & Landscape: Jane Frelicher, Yvonne
Jacquette, Altoon Sultan," Sleeth Gallery, West
Virginia Wesleyan College, Buckhannon,
WV, 1996
"New York Realism: Past and Present," Odyakyu
Museum, Tokyo. Traveled to Kagoshima City
Museum of Art; The Museum of Art, Osaka;
Fukushima Prefectural Museum of Art; Tampa
Museum of Art, FL, 1994-1995
"New York, New York: Recent Landscapes," North
Carolina Museum of Art, Raleigh, NC, 1994
"First Impressions: Early Prints by Forty-six Con-
temporary Artists," Walker Art Center, Minneapo-
lis, MN. Traveled to Laguna Gloria Art Museum,
Austin, TX; Baltimore Museum of Art, Baltimore,
MD; Neuberger Museum, State University of New
York, Purchase, NY, 1989
"Public & Private: American Prints Today," The
Brooklyn Museum, Brooklyn, NY, 1986

Selected Honors and Awards

Print Commission, The Jane Voorhees Zimmerli Art
Museum, Rutgers University, New Brunswick, NJ,
1993

Dennis Kardon

Born in Des Moines, Iowa, 1950
Lives and works in New York, NY
Educated at Yale University, New Haven, CT (B.A.
Cum Laude, 1973) and Whitney Museum of
American Art Independent Study Program (1973)

*Dennis Kardon,
1992*
Photograph by Phil Haggerty

Selected One-Person Exhibitions

Richard Anderson Fine Arts, New York, NY, 1996
"A Conversation with Rococo Mirrors," A/D Gallery,
New York, NY, 1991
Studio Space, Simon Watson, New York, NY, 1990
Barbra Toll Gallery, New York, NY, 1989, 1986,
1984, 1981

Selected Group Exhibitions

"Too Jewish? Traditional Identities," The Jewish Museum, New York, NY, 1996

"In the Flesh," The Albright Gallery, Reading, PA; The Aldrich Museum of Contemporary Art, Ridgefield, CT, 1995-1996

"The 1980's: Prints from the Collection of Joshua P. Smith," National Gallery of Art, Washington, DC, 1989

"Erotophobia," Simon Watson, New York, NY, 1987

"Public and Private: American Prints Today," The Brooklyn Museum, Brooklyn, NY, 1986

"Prints from Blocks: Gauguin to Now," The Museum of Modern Art, New York, NY, 1983

Selected Honors and Awards

Louis Comfort Tiffany Foundation Grant, Great Neck, NY, 1991

New York Foundation for the Arts Grant, 1987

Komar & Melamid

Vitaly Komar
Born in Moscow, 1943

Aleksandr Melamid
Born in Moscow, 1945

Live and work in New York, NY

Educated at Moscow Art School (1958-1960), and Stronganov Institute of Art and Design (1962-1967)

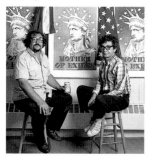

left to right:
Vitaly Komar and Aleksandr Melamid before Robert Indiana's Mother of Exiles, *1986*

Photograph by Jon Bonjour

Selected Joint Exhibitions

"Made to Order: America's Most Wanted Paintings," Alternative Museum, New York, NY, 1996

The Brooklyn Museum, Grand Lobby Installation, Brooklyn, NY, 1990

Artspace, Sydney, Australia. Traveled to Institute of Modern Art, Brisbane; School of Art Gallery, University of Tasmania; Australia Centre of Contemporary Art, Melbourne; Praxis, Perth; Experimental Art Foundation, Adelaide, 1987-1988

Museum of Contemporary Art, Chicago, IL (Lecture and Performance), 1981

The Hirshhorn Museum and Sculpture Garden, Smithsonian Institution, Washington, DC (lecture and performance), 1979

Ronald Feldman Fine Arts, 1992, 1991, 1989, 1984-1987, 1976-1982

Selected Group Exhibitions

"Fractured Fairy Tales," Duke University Museum of Art, Durham, NC, 1996

"From Gulag to Glasnost," The Jane Voorhees Zimmerli Art Museum, Rutgers University, New Brunswick, NJ, 1995

"Parallel Visions: Modern Artists and Outsider Art," Los Angeles County Museum of Art, Los Angeles, CA, 1992

"Committed to Print," The Museum of Modern Art, New York, NY, 1988

"Counterparts and Affinities," Metropolitan Museum of Art, New York, NY, 1982

Outdoor Exhibition, Beljaevo, Moscow, 1974 (exhibition bulldozed by authorities)

Selected Honors and Awards

Bronx Housing Court Lobby, Percent-for-Art Commission through New York City Department of Cultural Affairs, 1992-1995

Design for Boy and Girl Scouts' summer camp, commissioned by the Institute of Aviation, Moscow District, 1972

Robert Morris

Born in Kansas City, MO, 1931

Lives and works in Bridgeport, CT

Educated at Kansas City Art Institute, University of Kansas City, MO (1948-1950), California School of Fine Arts (1950-1951), Reed College, Portland, OR (1953-1955), and Hunter College, New York, NY (M.A., 1963)

Robert Morris reviewing proofs, 1988

Selected One-Person Exhibitions

"The Mind/Body Problem," Solomon R. Guggenheim Museum, New York, NY, 1994

Sonnebend Gallery, 1992, 1988, 1985, 1983, 1979, 1976, 1974, 1973, 1971

Leo Castelli Gallery, New York, NY, 1990, 1988, 1985, 1983, 1980, 1979, 1976, 1974, 1972, 1967-1970

"Inability to Endure or Deny the World: Representation and Text in the Work of Robert Morris," The Corcoran Gallery of Art, Washington, DC, 1990

"Robert Morris: The Work of the Eighties," Museum of Contemporary Art, Chicago, IL, 1986

"Robert Morris: Selected Works 1970-1981," Contemporary Arts Museum, Houston, TX, 1984

"The Drawings of Robert Morris," The Sterling and Francine Clark Art Institute. Traveled to The

Institute of Contemporary Art, Boston, MA;
Seattle Art Museum, Seattle, WA; Laguna Gloria
Art Museum, Austin, TX; Grand Rapids Art
Museum, Grand Rapids, MI, 1982

Selected Group Exhibitions
"American Art in the 20th Century: Painting and
 Sculpture 1913-1993," Martin-Gropius-Bau,
 Berlin. Traveled to Royal Academy of Arts,
 London, 1993
"Images of War: Callot, Goya, Poada, Morris,
 Sherman, Chagoya," Centro Cultural Arte
 Contemporano, Mexico City, Mexico, 1992
"Committed to Print," The Museum of Modern Art,
 New York, NY, 1988
"Directions 1986," Hirshhorn Museum, Washington,
 DC, 1986
"In Our Time," The Contemporary Arts Museum,
 Houston, TX, 1982
"American Drawings in Black and White," The
 Brooklyn Museum, Brooklyn, NY, 1980

Selected Honors and Awards
Skowhegan Medal for Progress and Environment,
 1978
John Simon Guggenheim Memorial Fellowship,
 1969

Alain Paiement

Born in Montréal, Québec, Canada, 1960
Lives and works in Montréal
Educated at Université du Québec à Montréal
(B.F.A., 1982), (M.F.A., 1987), additional studies at
École Nationale Supérieure des Arts Visuels de la
Cambre, Brussels (1983-1984), and Université de
Paris (1985-1986)

*Alain Paiement
assembling a proof of
Grand Amphitheater—
According to Horizon,
1989*

Selected One-Person Exhibitions
"Planisphéres 1986-1996," Galerie Langage +, Alma,
 Québec, 1996
"Sometimes Square," Musée d'Art Contemporain de
 Montréal, Québec, 1994
"Ampitheatres, (new version)," The Power Plant,
 Toronto, 1989
"Beyond Polders," Old Eckers Brewery, Montréal,
 1987
"Ampitheatres," Canadian Cultural Center, Paris,
 1986
"Waterdampstructuren (water-vapour-structures),"
 Apart Gallery, Montréal, 1985

Selected Group Exhibitions
"Instant Photographiques," Musée d'Art
 Contemporain de Montréal, 1995
"Inhabitable Places (Inhabitables Espaces)," Leonard
 and Bina Ellen Art Gallery, Concordia University,
 Montréal, 1994
"Photo Sculpture," Nickel Art Museum, Calgary.
 Traveled to Edmonton Art Gallery, Edmonton,
 Ontario; Oakville Art Galleries, Oakville;
 Dalhousie Art Gallery, Halifax, Nova Scotia;
 Musée Regional de Rimouski, Québec, 1992-1993
"The Power of the City/The City of Power,"
 Whitney Museum of American Art at the Federal
 Reserve Plaza, New York, NY, 1992
"Troisiéme Trienniale Internationale de la
 Photographie," Musée des Beaux-Arts, Charleroi,
 Belgium, 1987

Selected Honors and Awards
Mc Abbey Foundation, Montréal
E. Greenshield Foundation, Montréal
Ministère de la Communauté Française de Belgique
Canada Arts Council
Ministère de la Culture du Québec

Kingsley Parker

Born in Mt. Vernon, OH, 1947
Lives and works in New York, NY
Educated at Middlebury College, Middlebury, VT
(B.A., 1970), Hartford Art School, University of
Hartford, Hartford, CT (1972), School of the
Museum of Fine Arts, Boston, MA (1973-74), and
Hunter College, New York, NY (M.A., 1977)

*Kingsley Parker working
on a plate,
1986*

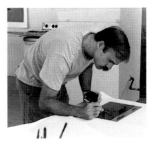

Selected One-Person Exhibitions
Condeso/Lawler Gallery, New York, NY, 1996,
 1994, 1991, 1989, 1987, 1985, 1984
Luce House Gallery, Martha's Vineyard, MA, 1994
Ellen Erpf Miller Fine Art, Waban, MA, 1987
Davidson Art Center, Wesleyan University,
 Middletown, CT, 1983
J. Fields Gallery, New York, NY, 1980

Selected Group Exhibitions
"Tendencias Contemporanes," Mexico City, Mexico.
 Traveled to Bogota, Columbia, 1995
"19th International Biennial of Graphic Art,"
 Ljubljana, Yugoslavia, 1991

"Intaglio Printing in the 1980s," The Jane Voorhees Zimmerli Art Museum, Rutgers University, New Brunswick, NJ, 1991

Krakow Print Triennial, Krakow, Poland, 1991

"Artwords and Bookworks," Los Angeles Institute of Contemporary Art, Los Angeles, CA, 1978

Selected Honors and Awards
Resident Fellowship, The Creative Glass Center of America, Wheaton Village, Millville, NJ, 1995

National Endowment for the Arts Artist Residency Grant, Avocet at Art Awareness, Lexington, NY, 1988

Alison Saar

Born in Los Angeles, CA, 1956
Lives and works in Los Angeles, CA
Educated at Scripps College, Clairmont, CA (B.A., 1978), and Otis Art Institute, Los Angeles, CA (M.F.A., 1981)

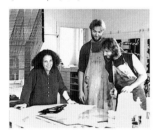

left to right:
Alison Saar, Jonathan Higgins, and Randy Hemminghaus, 1993

Selected One-Person Exhibitions
The Brooklyn Museum, Brooklyn, NY, 1996

"Strange Fruit," Phyllis Kind Gallery, New York, NY, 1995

"Alison Saar, Fertile Grounds + Crossroads," Virginia Museum of Fine Arts, Richmond, VA, 1994

"Directions: Alison Saar," Hirshhorn Museum and Sculpture Garden, Washington, DC, 1993

"Slow Boat," Whitney Museum of American Art at Phillip Morris, New York, NY, 1992

Jan Baum Gallery, Los Angeles, CA, 1990, 1988, 1987, 1985, 1983, 1982

Selected Group Exhibitions
"Black Male," Whitney Museum of American Art, New York, NY, 1994

"Localities of Desire," Museum of Contemporary Art, Sydney, Australia, 1994

"Bienale," Havana, Cuba, 1994

"Betye Saar and Alison Saar: House of Gris Gris," Contemporary Arts Center, New Orleans, LA, 1993

"Secrets, Dialogs, Revelations: The Art of Betye and Alison Saar," Wight Art Gallery, University of California, Los Angeles. Traveled to The Laguna Gloria Art Museum, Austin, TX; Museum of Contemporary Art, Chicago, IL; Smith College

Museum of Art, Northampton, MA; The Contemporary Arts Center, Cincinnati, OH; The Oakland Museum, Oakland, CA, 1990

"Decade Show," The New Museum, New York, NY, The Studio Museum in Harlem, New York, NY, Museum of Contemporary Hispanic Art, New York, NY, 1990

"The 1980s: A New Generation," Metropolitan Museum of Art, New York, NY, 1988

Selected Honors and Awards
John Simon Guggenheim Memorial Fellowship, 1989

National Endowment for the Arts Fellowship, 1988

Peter Saul

Born in San Francisco, CA, 1934
Lives and works in Austin, TX
Educated at Stanford University, Stanford, CA (1950-1952), California School of Fine Arts, San Francisco (1950-1952), and Washington University, St. Louis, MO (B.F.A., 1956)

Peter Saul working on Superwoman monotypes, 1995

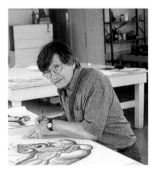

Selected One-Person Exhibitions
"Castro's Mother Destroys Miami and Related Drawings," Drawing Gallery, Frumkin/Adams Gallery, 1995

"Peter Saul: Political Paintings," Frumkin/Adams Gallery. Traveled to Krannert Art Museum, University of Illinois, Champaign, IL; Washington University Art Gallery, St. Louis, MO, 1990-1991

"Peter Saul," Aspen Art Museum, Aspen, CO. Traveled to Museum of Contemporary Art, Chicago, IL; Laguna Gloria Art Museum, Austin, TX; Contemporary Art Center, New Orleans, LA, 1989-1990

Swen Parson Gallery, University of Northern Illinois, Dekalb, IL. Traveled to Madison Art Center, Madison, WI, 1980-1981

Allan Frumkin Gallery, New York, NY, 1987, 1985, 1984, 1981, 1978, 1975, 1973, 1971, 1969, 1968

Selected Group Exhibitions
"Facing Eden: 100 Years of Bay Area Landscape Art," M.H. de Young Memorial Museum, San Francisco, CA, 1996

"Hand-Painted Pop: American Art in Transition, 1955-1962," The Museum of Contemporary Art, Los Angeles. Traveled to Museum of Contemporary Art, Chicago, IL; Whitney Museum of American Art, New York, NY, 1992-1993

"A Different War: Vietnam in Art," Madison Art Center, WI, 1990

"Repulsion: Aesthetics of the Grotesque," Alternative Museum, New York, NY, 1987

"Painting and Sculpture in California: The Modern Era," San Francisco Museum of Modern Art, San Francisco, CA. Traveled to National Collection of Fine Arts, Washington, DC, 1976-1977

Selected Honors and Awards
National Endowment for the Arts Fellowship, 1980
New Talent Award, *Art in America* magazine, 1966
William and Norma Copley Foundation Grant, 1962

Joan Thorne

Born in Brooklyn, NY, 1944
Lives and works in New York, NY
Educated at New York University, NY (B.S., 1965) and Hunter College, New York, NY (M.F.A., 1968)

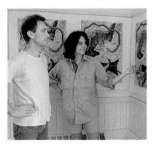

Maurice Payne and Joan Thorne reviewing proofs for Absalo, *1985*

Photograph by Alice Bissle

Selected One-Person Exhibitions
Museo Voluntariado de las Casas Reales, Casa de Bastidas, Santo Domingo, Dominican Republic, 1998

Rampo College, NJ, 1996
Graham Modern, New York, NY, 1990, 1988, 1985
Ruth Bachofner Gallery, Los Angeles, CA, 1989
Lincoln Center Gallery, Lincoln Center, New York, NY, 1983
The Corcoran Gallery of Art, Washington, DC, 1973

Selected Group Exhibitions
"News, Surprise and Nostalgia," Bertha and Karl Leubsdorf Art Gallery, Hunter College, New York, NY, 1995

"The Exuberant '80s," Andre Zarre Gallery, New York, NY, 1994

"Abstract Painting of the '90s," André Emmerich Gallery, New York, NY, 1991

"Diptychs, Triptychs, Polyptychs," Graham Modern, 1986

"Works on Paper," Weatherspoon Gallery, Greensboro, NC, 1984

Selected Honors and Awards
Prix de Rome, American Academy in Rome, 1986
Pollock/Krasner Foundation Grant in Painting, 1986
National Endowment for the Arts Fellowship, 1983, 1979
New York State Council on the Arts, Grant for Painting, 1975, 1980
Artist of the Year, Aldrich Foundation, 1972

Robert Zakanitch

Born in Elizabeth, NJ, 1935
Lives and works in Brooklyn, NY
Educated at Newark School of Fine and Industrial Arts, Newark, NJ (1954-1957)

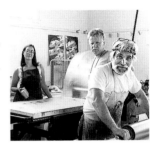

left to right:
Barbara McGill Balfour, Robert Zakanitch, and Julio Juristo, 1986

Selected One-Person Exhibitions
Locks Gallery, Philadelphia, PA, 1996
University of Iowa, Museum of Art, Iowa City, IA, 1995
Robert Miller Gallery, New York, NY, 1988, 1985, 1984, 1981, 1979, 1978
Institute of Contemporary Art, University of Pennsylvania, Philadelphia, PA, 1981
Henri Gallery, Alexandria, VA, 1965

Selected Group Exhibitions
"Focus on the Image: Selections from the Rivendell Collection," organized by the Art Museum Association of America and originating at Phoenix Art Museum, Phoenix, AZ, 1986

"Abstract Painting Redefined," Louis K. Meisel Gallery, New York, NY, 1985

"Prints from Tyler Graphics," Walker Arts Center, Minneapolis, MN, 1984

"Morton G. Neumann Family Collection: Selected Works," organized by the National Gallery of Art, Washington, DC. Traveled, 1980

"Thirty-Ninth Venice Biennial," Venice, Italy, 1980

"Thirty-Third Biennial Exhibition," The Corcoran Gallery of Art, Washington, DC, 1973

Selected Honors and Awards
John Simon Guggenheim Memorial Fellowship, 1995
New York State Council on the Arts, CAPS Grant, 1970

Frank Akers

Educated at Illinois Institute of Technology, Chicago, IL, The Art Institute of Chicago, Chicago, IL (B.F.A. and M.F.A. in Printmaking and Graphics), and Tamarind Lithography Workshop, Los Angeles, CA

Selected Professional Experience
Shop manager/master printer, Vinalhaven Press, Vinalhaven, ME, 1987
General manager, Chromacomp, Inc., 1986
Technical director, Atelier Ettinger, Inc., New York, NY, 1984-1985
Printmaking Instructor, Bennington College, Bennington, VT, 1974-1979
Assistant professor, Hartford Art School, University of Hartford, Hartford, CT, 1971-1974
Master printer/shop manager, Universal Limited Art Editions, West Islip, NY, 1970-1971

Selected Collaborations
Billy Al Bengston, Chryssa, Al Held, Jasper Johns, Alex Katz, Marisol, David Milne, Ed Moses, Alice Neel, José Ortega, Robert Rauschenberg, James Rosenquist, Adolf Schering

Selected Honors and Awards
Ford Foundation Grant, Tamarind Lithography Workshop, 1967-1968

Lynne Allen

Educated at Kutztown University, Kutztown, PA (B.S., Art Education, 1970), University of Washington, Seattle, WA (M.A., 1973), Tamarind Institute, Albuquerque, NM, (master printer certification 1982), and University of New Mexico, Albuquerque, NM (M.F.A., 1986)

Selected Professional Experience
Associate professor, Mason Gross School of the Arts, Rutgers, The State University of New Jersey, New Brunswick, NJ, 1989-present
Associate director, Rutgers Center for Innovative Printmaking, Department of the Visual Arts, Mason Gross School of the Arts, Rutgers, The State University of New Jersey, 1987- present
Master printer, Rutgers Center for Innovative Printmaking, 1987-1989
Master printer, Vinalhaven Press, Vinalhaven, ME, 1985

Educational/technical director; master printer/shop manager, Tamarind Institute, The University of New Mexico, 1982-1987
Art department chair, American School of the Hague, The Netherlands, 1975-1980

Selected Collaborations
Janet Fish, Leon Golub, Haminishi, Wolf Kahn, Grete Marstein, George McNeil, Philip Pearlstein, Faith Ringgold, Juan Sanchez

Selected Honors and Awards
Board of Trustees Research Fellowship Award, Rutgers University, 1995
Fulbright Scholarship, Lecture Grant to the Sorikov Art Institute, Moscow, Russia, 1990

Barbara McGill Balfour

Educated at Smith College, Northampton, MA (B.A., 1980), Ontario College of Art, Toronto, Ontario (A.O.C.A. Fine Art, 1984), and Concordia University, Montréal, Québec (M.F.A., 1988)

Selected Professional Experience
Professor, Department of Printmaking, Concordia University, 1991-present
Visiting artist, University of Calgary, Alberta, 1992
Visiting artist, East Tennessee State University, Johnson City, TN, 1991
Visiting artist, Nova Scotia College of Art and Design, Halifax, Nova Scotia, 1990
Master printer, Vinalhaven Press, Vinalhaven, ME, 1989-1990

Selected Collaborations
Leon Golub, Robert Indiana, Komar & Melamid, David Rabinowitch

Selected Honors and Awards
Arts Grant "B," Canada Council, 1995-1996
Long-term Grant, Bouse de soutien à la pratique artistique, Conseil des arts et des lettres du Québec, 1993-1994
Project Grant, Canada Council, 1991
Resources Techniques Grant, Ministére des Affaires culturelles, Quebec, 1987-1989

James Davies Cambronne

Educated at Augustana College, Sioux Falls, SD (B.F.A., 1983), Yale University School of Art, New Haven, CT (M.F.A., 1985)

Selected Professional Experience
Associate professor of art, Maine College of Art, Portland, ME, 1987-present
Master printer, Anderson Ranch Arts Center Press, Snowmass Village, CO, 1994-1995
Master printer, Coyote Love Press, Portland, ME, 1988-1989
Master printer, Vinalhaven Press, Vinalhaven, ME, 1991
Instructor, Yale University School of Art, New Haven, CT, 1985-1987

Selected Collaborations
Mary Bate, Lenore Berman, Thomas Cornell, Nancy Davies, Charles Hewitt, James Howard, Robert Indiana, James Kielkoph, Brian Leo, Rudy Pozatti, Sam Reveler, Jerry Rudquist, Abby Shahn, Rochelle Woldoski

Selected Honors and Awards
Resident Artist, Anderson Ranch Arts Center, 1994-1995
NYNEX Award for Excellence in Teaching Art 1990-1995

Kathleen Caraccio

Educated at Herbert H. Lehman College, Bronx, NY (B.F.A., 1971)

Selected Professional Experience
Founder/director, K. Caraccio Etching Studio, New York, NY, 1977-present
Printmaking instructor, Manhattan Graphic Arts Center, New York, NY, 1991-1995
Printmaking instructor, New York University, New York, NY, 1990-1996
Master printer, Vinalhaven Press, Vinalhaven, ME, 1985
Master printmaking preceptor, Bennington College, Bennington, VT; Brown University, Providence, RI; Coe College, Cedar Rapids, IA;Cooper Union, New York, NY; Cornell University, Ithaca, NY; Drew University, Madison, NJ; Lehman College, Bronx, NY; Lewis and Clark College, Portland, OR; New York University; Parsons/The New School, New York, NY; Princeton University, Princeton, NJ; and Rollins College, Winter Park, FL; 1977-1996
Hanga (japanese woodblock printing) instructor, The Printmaking Workshop, New York, NY, 1974-1995

Selected Collaborations
Emma Amos, Jackie Battenfield, Ed Baynard, Romare Bearden, Mel Bochner, Arun Bose, Paul Brach, Lamar Briggs, Brodsky & Utkin, Alan Cober, Stephen Edlich, Nicholette Jelen, Frances Jetter, Robert W. Kelly, Hugh Kepets, Robert Kipniss, Martin Levine, Sol Lewitt, Stephen Lorber, Lynn Newcomb, Louise Nevelson, Richard Pitts, Michael Ponce de Leon, Harriet Shorr, Michael Steiner, Peter Stevens, Emily Trueblood, Jerry West, Joel Peter Witkin

Selected Honors and Awards
Rutgers Archive for Printmaking Studios Grant, 1995, 1989, 1984
Medal of Honor, Catherine Lorrilard Wolfe Art Club, 1994
Louis Comfort Tiffany Foundation Grant, 1979

Orlando Condeso

Educated at School of Visual Arts, National School of Engineers, Lima, Peru (1969), Pratt Graphics Center, New York, NY (1971)

Selected Professional Experience
Co-owner, Condeso/Lawler Ltd., 1980-present
Independent master printer, New York, NY, 1973-present
Etching instructor, New Jersey Center for Visual Arts, Summit, NJ, 1989-1990
Master printer, Vinalhaven Press, Vinalhaven, ME, 1985-1989
Instructor, Lower Eastside Printshop, New York, NY, 1982-1984; 1973-1977
Master printer, The Printmaking Workshop, New York, NY, 1972

Selected Collaborations
Louisa Chase, Susan Crile, Janet Fish, Jane Freilicher, Richard Haas, Robert Indiana, Alex Katz, Vincent Longo, Robert Morris, Philip Pearlstein, Susan Shatter, Jack Youngerman

Selected Honors and Awards
Pratt Graphics Center Award, New York, NY, 1972
First Prize, VI National Print Competition, Lima, Peru, 1970

John C. Erickson

Educated at Minnesota College of Art and Design, Minneapolis, MN (1962-1963), University of Minnesota School of Architecture (1963-1968), and University of Minnesota, Minneapolis, MN (1970-1972)

Selected Professional Experience
Independent master printer and publisher, 1976-present
Master printer, Vinalhaven Press, Vinalhaven, ME, 1985-1990
Established and headed lithography section of Styria Studio, New York, NY, 1972-1976
Assistant printer, Universal Limited Art Editions, West Islip, NY, 1971

Selected Collaborations
Arakawa (Shusaku), Richard Bosman, Louisa Chase, Dan Flavin, Robert Indiana, Yvonne Jacquette, Alex Katz, Komar & Melamid, Roy Lichtenstein, Brice Marden, Marisol, Claes Oldenburg, Robert Rauschenburg, Larry Rivers, James Rosenquist, Susan Rothenberg, Edward Ruscha, Alison Saar, Richard Serra, Joan Snyder, Saul Steinberg

William Haberman

Educated at University of Wyoming, Laramie, WY (B.F.A., 1975-1979), Tamarind Institute, Albuquerque, NM (master printer certificate, 1980-1982), and University of New Mexico, Albuquerque, NM (B.F.A., 1983-1985, M.F.A., 1985-1987)

Selected Professional Experience
Printmaking instructor, Hellidens Folkhogskola, Grafiska Verkstaden, Tidaholm, Sweden, 1995-1997
Master printer, Oberon Press, New York, NY, 1991-1995
Master printer/instructor, Rutgers Center for Innovative Printmaking, New Brunswick, NJ, 1986-1991
Master printer, Western Graphics, Albuquerque, NM, 1981-1986

Selected Collaborations
Richard Bosman, Vija Celmins, Louisa Chase, Janet Fish, Jane Freilicher, Robert Mangold, Mel Ramos, Juan Sanchez, Robert Shapiro, Steve Sorman, John Walker, William Wegman, William T. Williams

Selected Honors and Awards
Visiting artist, Union of Soviet Artists, Moscow, 1991
Visiting artist, Tidaholm Graphic Workshop, 1993, 1987-1989

Randy Hemminghaus

Educated at Ontario College of Art, Toronto, Ontario (A.O.C.A. Fine Art, 1982), and Concordia University, Montréal, Québec (M.F.A., 1991)

Selected Professional Experience
Master printer and co-proprietor, Galamander Press, 1995-present
Master printer, Vinalhaven Press, Vinalhaven, ME, 1986-1996
Master printer, Fox Graphics, Merrimac, MA, 1991
Freelance printer, 1985-1995

Selected Collaborations
José Bedia, Grisha Brushkin, Mel Chin, Dorothy Dehner, Leon Golub, David Hare, Charles Hewitt, Robert Indiana, Komar & Melamid, Jean-Paul Riopelle, Alison Saar, Peter Saul

Jonathan K. Higgins

Educated at Humbolt State University, Arcata, CA (B.F.A., 1987) and New York University, New York, NY (M.F.A., 1992)

Selected Professional Experience
Master printer and co-proprietor, Galamander Press, 1995-present
Master printer, Vinalhaven Press, Vinalhaven, ME, 1993-1996
Master printer, Branstead Studio, New York, NY, 1991
Master printer, The Printmaking Workshop, New York, NY, 1993
Printer, K. Caraccio Etching Studio, New York, NY, 1990-1991
Printer, Kala Institute, Berkeley, CA, 1989
Printer, D. Smith Harrison Studio, Emeryville, CA, 1988-1989

Selected Collaborations
José Bedia, Mel Chin, Robert Indiana, Alison Saar, Peter Saul

Julio Juristo *(1927-1995)*

Selected Professional Experience
Founder/director, Topaz Editions, Inc., Tampa, FL, 1973-1995
Master printer, Vinalhaven Press, Vinalhaven, ME, 1986
Master printer, Pyramid Arts, Ltd., 1976
Master printer, Graphicstudio, University of South Florida, Tampa, FL, 1971-1976
Employed at Grumman Aerospace Corporation (positions included prototype structural group leader, flight development plane captain, vehicle launch team member for the Lunar Module, Apollo 9 - Apollo 14), Cape Canaveral, FL, 1952-1970

Selected Collaborations
Richard Anueszkiewicz, Arakawa (Shusaku), John Chamberlain, Dorothy Dehner, Jim Dine, Philip Pearlstein, Larry Poons, Katherine Porter, Robert Rauschenberg, James Rosenquist, Fritz Scholder, Robert Zakanitch

Selected Honors and Awards
Tamarind Institute Guest Artist, 1975
National Endowment for the Arts Fellowship, 1975
Ford Foundation Grant, Tamarind Institute, 1970-1971

Anthony Kirk

Educated at Newcastle College of Art, England, (1968-1969), Winchester School of Art, England, (1969-1972), and Chelsea School of Art, England (M.F.A., 1973)

Selected Professional Experience
Master printer, intaglio, Tyler Graphics, Mt. Kisco, NY, 1988-present
Printmaking instructor, Manhattan Graphics Center, NY, 1990-present
Owner/director, Eldindean Press, New York, NY, 1976-1988
Printmaking instructor, Parsons School of Design, New York, NY; Pratt Graphic Center, New York, NY; The Printmaking Workshop, New York, NY; Summit Art Center, Summit, NJ, 1976-1988
Freelance master printer, New York, NY, 1975-1976

Selected Collaborations
Arakawa (Shusaku), Richard Artschwager, Janet Fish, Helen Frankenthaler, Red Grooms, Charles Hewitt, Robert Indiana, Yvonne Jacquette, Terence LaNoue, Joan Mitchell, John Newman, Karl Schrag, Steven Sorman, Frank Stella, Altoon Sultan, Masami Teraoka, John Walker

Selected Honors and Awards
Advisory board, Manhattan Graphics Center, New York, NY, 1990-present

Sylvia Roth

Educated at New York University, New York, NY (B.F.A., 1954)

Selected Professional Experience
Master printer, Vinalhaven Press, Vinalhaven, ME, 1986
Founder/master printer, Hudson River Editions, South Nyack, NY, 1981-present

Selected Collaborations
John Beerman, April Gornik, Alfonso Ossorio, Milton Resnick, Lewis Thomas

Selected Honors and Awards
Subscription Prize, Rutgers Printmaking Archives, The Jane Voorhees Zimmerli Art Museum, New Brunswick, NJ, 1986, 1985, 1983
C.E.T.A. Grant to establish etching atelier at Rockland Center for the Arts, West Nyack, NY, 1977

Brenda Zlamany

Educated at Wesleyan University, Middletown, CT (B.F.A., 1981), Atelier 17, Paris (1981), Tyler School of Art, Rome (1981), and Skowhegan School of Painting and Sculpture, Skowhegan, ME (1984)

Selected Professional Experience
Founder/head etching printer, Erie-Lackawanna Editions, Brooklyn, NY, 1985-present
Master printer, Vinalhaven Press, Vinalhaven, ME, 1990-1991
Master etching printer, Jeryl Parker Editions, New York, NY, 1981-1986

Selected Collaborations
Ida Applebroog, Mel Bochner, Francesco Clemente, Robert Cumming, Christian Eckart, Jane Kent, Robert Kushner, Jonathan Lasker, Carl Ostendarp, Betty Parsons, David Salle, Julian Schnabel, Donald Sultan, David True

Selected Honors and Awards
MacDowell Colony, Peterborough, NH, 1995, 1992, 1986
New York Foundation for the Arts Fellowship in Painting, 1994
Jerome Foundation Fellowship, Printmaking Workshop, New York, NY, 1981-82

Works Published by the Vinalhaven Press

Measurements are in inches, height preceding width. Date indicates the year the work was editioned and signed by the artist, and may be different from the year the work was developed. Titles of works in the exhibition **In Print: Contemporary Artists at the Vinalhaven Press** are in boldface type, marked with an (•), and with the lending collection indicated. For biographical information on the artists, see pages 68-79.

José Bedia

Monotypes, 1994
Rives BFK paper
printed by Randy Hemminghaus

• *YaYa*
variable edition of 3
image and sheet: 28 1/$_4$ x 43 13/$_{16}$
Courtesy Vinalhaven Press

La Caida
variable edition of 3
image and sheet: 28 3/$_8$ x 43 3/$_8$

Opuestos
variable edition of 2
image and sheet: 28 5/$_{16}$ x 43 5/$_{16}$

Hombre Perro
variable edition of 3
image and sheet: 28 5/$_{16}$ x 43 5/$_{16}$

Centauro
variable edition of 2
image and sheet: 28 5/$_{16}$ x 43 1/$_2$

• *Ciclón vs Rayo*, 1994
soft-ground etching, aquatint, and chine collé
Rives BFK paper
edition of 45; 15 on yellow Moriki chine collé,
 15 on red Moriki chine collé, 15 on Okawara
 chine collé
printed by Randy Hemminghaus, Jonathan Higgins,
 and Scott Smith
image: 9 x 22, sheet: 14 3/$_4$ x 30
Private collection (Red Moriki)
Courtesy Vinalhaven Press (Okawara)

Yo Puedo Más que Tú, 1994
soft-ground etching, aquatint, and chine collé
Rives BFK paper
edition of 30; 15 on yellow Moriki chine collé,
 15 on Okawara chine collé
printed by Randy Hemminghaus, Jonathan Higgins,
 and Scott Smith
image: 9 x 22, sheet: 14 3/$_4$ x 30

• *Dobles*, 1994
lithograph and Okawara chine collé
Rives BFK paper
edition of 20
printed by Randy Hemminghaus
 and Kathleen Beckert
image: 22 x 30, sheet: 30 x 38
Courtesy Vinalhaven Press

• *Jibaro*, 1994
lithograph, woodcut, and Okawara chine collé
Arches Cover paper
edition of 6
printed by Randy Hemminghaus
 and Kathleen Beckert
image: 15 x 22 (each), sheet: 36 x 50
Courtesy Vinalhaven Press

John Beerman

Two Rocks, 1987
lithograph
Arches Cover paper
edition of 28
printed by John C. Erickson
image: 40 1/$_2$ x 27 1/$_8$, sheet: 41 1/$_2$ x 28 1/$_2$

Vinalhaven Series I - XXIX, 1986
monotype
Rives BFK paper
variable edition of 29
printed by Sylvia Roth and Johanna Hesse
image: 14 5/$_8$ x 22, sheet: 22 x 30

Mel Bochner

Day's Cove, 1985
soft-ground etching and aquatint
Rives BFK paper
edition of 20
printed by Maurice Payne and Kathleen Caraccio
image: 13 $^3/_4$ x 30, sheet: 13 $^3/_4$ x 19 $^7/_8$

Iron Point, 1985
soft-ground etching and aquatint
Rives BFK paper
edition of 20
printed by Maurice Payne and Kathleen Caraccio
image: 18 x 14, sheet: 30 x 22

Winter Harbor I, 1985
soft-ground etching and aquatint
Arches Cover paper
edition of 15
printed by Kathleen Caraccio
image: 23 $^3/_4$ x 17 $^1/_2$, sheet: 30 x 22

Winter Harbor II, 1985
soft-ground etching and aquatint
Arches Cover paper
edition of 15
printed by Kathleen Caraccio
image: 23 $^3/_4$ x 17 $^1/_2$, sheet: 30 x 22

White Island, 1985
soft-ground etching and aquatint
Rives BFK paper
edition of 30
printed by Maurice Payne and Orlando Condeso
image: 29 $^5/_8$ x 22 $^7/_8$, sheet: 37 $^1/_8$ x 29 $^1/_2$

Peter Bodnar

Vinalhaven I, 1985
lithograph
Rives BFK paper
edition of 10
printed by William Haberman
image: 10 x 8, sheet: 12 $^1/_4$ x 10 $^1/_4$

Vinalhaven II, 1985
lithograph and hand-coloring
Arches Cover paper
edition of 16
printed by William Haberman
image: 12 x 15 $^3/_4$, sheet: 15 x 18 $^7/_8$

Carolyn Brady

Double Iris (color), 1985
hard-ground etching and aquatint
 printed à la poupée
Rives BFK paper
edition of 45
printed by Maurice Payne
image: 30 x 22, sheet: 36 $^1/_4$ x 29 $^1/_2$

Double Iris (black), 1985
hard-ground etching and aquatint
Rives BFK paper
edition of 10
printed by Maurice Payne
image: 20 x 14
sheet: 29 $^1/_2$ x 21 $^3/_4$

Erosia I, 1985
in collaboration with Robert Indiana
lithograph and monotype
Arches Cover paper
variant edition of 11; 3 printed in sepia and
 1 impression printed in each of the following
 colors: yellow, red, pink, green, purple, blue,
 orange, and multi-colored
printed by John C. Erickson and Michelle French
image and sheet: 30 $^1/_2$ x 22 $^1/_4$

Erosia II, 1985
in collaboration with Robert Indiana
lithograph
German Etching paper
edition of 28
printed by John C. Erickson and Michelle French
image and sheet: 30 $^1/_2$ x 22 $^1/_4$

Single Iris, 1985
hard-ground etching and aquatint
Rives BFK paper
edition of 20
printed by Maurice Payne
image: 20 x 14, sheet: 29 $^1/_2$ x 21 $^3/_4$

Grisha Bruskin

Co-published by Vinalhaven Press and
 Marlborough Gallery, New York

Lexica, 1992
portfolio of five (*Anghel*, *Ptitza*, *Glaza*, *Strela*,
 Litza)
hard-ground etching and aquatint
Rives BFK paper
edition of 24
printed by Randy Hemminghaus, Jonathan Higgins,
 Amy Bergin, and Wendy Newman
image: 9 x 7 $^1/_2$ (each), sheet: 13 $^1/_2$ x 17 $^3/_4$ (each)
Courtesy Vinalhaven Press

Louisa Chase

Co-published by Vinalhaven Press
 and Diane Villani Editions

Nightfall, 1985
hard-ground etching, aquatint, and drypoint
Rives BFK paper
edition of 15
printed by Orlando Condeso and Susan Volker
image: 19 $^7/_8$ x 17 $^3/_4$, sheet: 22 $^1/_2$ x 24 $^3/_4$

Untitled (Face to Face), 1985
hard-ground etching
Rives BFK paper
edition of 45; 15 each with blue, pink, or yellow
roll printed by Orlando Condeso and Susan Volker
image: 4 $^3/_8$ x 3 $^7/_8$, sheet: 11 $^3/_4$ x 11 $^1/_4$

Untitled (blue), 1985
hard-ground etching and aquatint
Rives BFK paper
edition of 15
printed by Orlando Condeso and Susan Volker
image: 5 $^7/_8$ x 5 $^3/_8$, sheet: 12 x 11 $^1/_4$

Untitled (pink), 1985
hard-ground etching and aquatint
Rives BFK paper
edition of 15
printed by Orlando Condeso and Susan Volker
image: 11 $^3/_4$ x 9 $^7/_8$, sheet: 16 $^3/_4$ x 15

Woods, 1985
hard-ground etching, aquatint, and drypoint
Rives BFK paper
edition of 15
printed by Orlando Condeso and Susan Volker
image: 17 $^5/_8$ x 19 $^3/_4$, sheet: 22 $^1/_2$ x 24 $^3/_4$

Mel Chin

Flag of the Agricultural Revolution, 1996
woodcut
Ysai woodgrain paper
edition of 20
printed by Randy Hemminghaus
 and Jonathan Higgins
image: 22 x 30, sheet: 25 x 35

The Language of Birds, 1996
soft-ground etching, aquatint and lithograph
black German Etching paper
edition of 20
printed by Randy Hemminghaus
 and Jonathan Higgins
image and sheet: 20 x 30

Revival Ramp, 1996
hard- and soft-ground etching, engraving, photo-
 etching and lithograph
Arches Cover paper
edition of 20
printed by Randy Hemminghaus and
 Jonathan Higgins
image: 30 x 30, sheet: 34 x 34

Self-Portrait (Bison and Hare), 1996
hard-ground etching and aquatint
Rives BFK paper
edition of 20
printed by Randy Hemminghaus and
 Jonathan Higgins
image: 11 x 22, sheet: 17 $^1/_4$ x 28

*Imperfect Pearls in the Ether
of Eternal Labor* , 1996
woodcut and lithograph
Okawara paper
edition undetermined
printed by Randy Hemminghaus
 and Jonathan Higgins
image: 15 $^3/_8$ x 22 $^1/_2$, sheet: 19 x 34

Susan Crile

Lane Preserve, 1987
hard-ground etching and aquatint
Arches Cover paper
edition of 30
printed by Orlando Condeso and Susan Volker
image: 23 $^3/_4$ x 36 $^3/_8$, sheet: 30 x 45
co-published by Vinalhaven Press and Graham
 Modern Gallery, New York

Thoroughfare, 1987
hard-ground etching and aquatint
Arches Cover paper
edition of 30
printed by Orlando Condeso and Susan Volker
image: 17 $^1/_2$ x 47 $^5/_8$, sheet: 24 x 53 $^3/_4$
co-published by Vinalhaven Press and Graham
 Modern Gallery, New York

Ragtime, 1989
woodcut
Hitachi paper
edition of 26
printed by John C. Erickson, Katherine Kreisher,
 Andrew Bloom, and Celeste Bard
image: 29 x 24, sheet: 39 x 24

The Weaver Sleeps, 1989
woodcut
Shoji paper
edition of 29
printed by John C. Erickson, Monica Torrebiarte,
 and Jessica Rice
image: 12 x 12, sheet: 20 $^{1}/_{2}$ x 17

Robert Cumming

Monotypes, 1987
Arches Cover paper
printed by John C. Erickson
sheet: 22 x 30

Islands: Penobscot Bay (Courtesy Vinalhaven
Press), *Cool Comma, Check Comma, Cut-Out
Comma/Apostrophe* (Museum of Fine Arts, Bos-
ton, Lee M. Friedman Fund, 1988.227-229), *Untitled
(Cup)*, *Islands in the Penobscot, Black Ball*

National Geographic Series
*Black Shoe, Small Black Ball, Fiddle, One of Two,
Fiddle, Two of Two, Twilight Fishing, July*

Fours/Fives, 1987
lithograph
Rives BFK paper
edition of 34
printed by John C. Erickson
image: 25 x 33, sheet: 29 $^{1}/_{2}$ x 37 $^{1}/_{2}$
Courtesy Vinalhaven Press

Monotypes, 1988
Arches Cover paper
variable editions of 2
printed by John C. Erickson
image and sheet: 22 $^{1}/_{4}$ x 30

*Skies of Blue, Baltic Rule, Domestic Rule, Elgin,
Odessa, Chemistry, Machine, Swiss Army Knife,
Industry* (Courtesy Vinalhaven Press)

Odessa, 1988
woodcut
Shoji paper
edition of 18
printed by John C. Erickson and Robert MacDonald
image and sheet: 47 x 35

Alexandria, 1989
woodcut
Shoji paper
edition of 30
printed by John C. Erickson and Robert MacDonald
sheet: 47 x 35
Portland Museum of Art, Maine. Museum Purchase
 with a gift from Roger and Katherine Woodman,
 1995.54

Small Chemistry, 1989
woodcut
Shoji
edition of 30
printed by John C. Erickson
image: 8 x 10, sheet: 15 x 20

Palette, Pedestal I, 1991
spit-bite aquatint and hard-ground etching
Rives BFK paper
edition of 25
printed by Brenda Zlamany and Peter Suchecki
image: 23 $^{7}/_{8}$ x 19 $^{7}/_{8}$, sheet: 36 $^{7}/_{8}$ x 26 $^{7}/_{8}$
Courtesy Vinalhaven Press

Palette, Pedestal II, 1991
spit-bite aquatint and hard-ground etching
Rives BFK paper
edition of 25
printed by Brenda Zlamany and Peter Suchecki
image: 23 $^{7}/_{8}$ x 19 $^{7}/_{8}$, sheet: 36 $^{7}/_{8}$ x 26 $^{7}/_{8}$

Palette, Pedestal State I, 1991
hard-ground etching
Rives BFK paper
edition of 10
printed by Brenda Zlamany and Peter Suchecki
image: 23 $^{7}/_{8}$ x 19 $^{7}/_{8}$, sheet: 36 $^{7}/_{8}$ x 26 $^{7}/_{8}$
Courtesy Vinalhaven Press

Palette, Pedestal State II, 1991
hard-ground etching
Rives BFK paper
edition of 10
printed by Brenda Zlamany and Peter Suchecki
image: 23 $^{7}/_{8}$ x 19 $^{7}/_{8}$, sheet: 36 $^{7}/_{8}$ x 26 $^{7}/_{8}$

Arcadia Suite, 1991
portfolio of four (*Primavera, Messiah, Baroque
 Trumpet, Two Klaviers*)
hard-ground etching
Rives BFK paper
edition of 30
printed by Brenda Zlamany, Brendan O'Malley, and
 Michael Hairston
image: 4 $^{7}/_{8}$ x 4 $^{7}/_{8}$ (each), sheet: 15 x 10 $^{1}/_{2}$ (each)

Patrick Dunfey

Marker, 1987
lithograph and watercolor
Rives BFK paper
edition of 26
printed by John C. Erickson
image: 17 $^3/_4$ x 9 $^1/_4$, sheet: 21 x 13

Mexico, 1987
lithograph and watercolor
Rives BFK paper
edition of 27
printed by John C. Erickson
image: 17 $^3/_4$ x 9 $^1/_4$, sheet: 21 x 13

Aaron Fink

Double Hats, 1987
woodcut and lithograph
Mino paper
edition of 30
printed by Frank Akers and Randy Hemminghaus
image and sheet: 25 x 39

Two Heads, 1987
woodcut and lithograph
Rives BFK paper
edition of 16
printed by Frank Akers and Randy Hemminghaus
image: 26 $^1/_2$ x 40, sheet: 28 $^1/_2$ x 41 $^1/_4$

Leon Golub

Facings: Black Men/ Black Women, 1988
diptych
lithograph
Arches Cover paper
edition of 32
printed by Barbara McGill Balfour
 and Randy Hemminghaus
sheet: 29 $^1/_2$ x 41 $^1/_2$ (each)

Classic Head? Claw Hand, 1989
lithograph
Rives BFK paper
edition of 42
printed by Barbara McGill Balfour
sheet: 22 x 30

Charles Hewitt

Clockers Fancy (color), 1986
woodcut and linocut
German Etching paper
edition of 15
printed by Anthony Kirk, George Bartko,
 and Marie Arcand
image: 31 x 20, sheet: 35 x 24

Clockers Fancy (grey), 1986
woodcut and linocut
German Etching paper
edition of 10
printed by Anthony Kirk, George Bartko,
 and Marie Arcand
image: 31 x 20, sheet: 35 x 24

Iago I, 1986
woodcut
Unryu paper
edition of 4
printed by Anthony Kirk, George Bartko,
 and Marie Arcand
sheet: 46 $^{11}/_{16}$ x 34 $^5/_8$

Iago II, 1986
woodcut
Unryu paper
edition of 9
printed by Anthony Kirk, George Bartko,
 and Marie Arcand
sheet: 46 $^7/_8$ x 34 $^7/_8$
Portland Museum of Art, Maine. Museum Purchase
with a gift from Joan B. Burns, 1986.249

Iago III, 1986
woodcut
Unryu paper
edition of 4
printed by Anthony Kirk, George Bartko,
 and Marie Arcand
sheet: 46 $^{11}/_{16}$ x 34 $^5/_8$

Memorial, 1986
woodcut and pochoir
Shoji paper
edition of 5
printed by Anthony Kirk, George Bartko,
 and Randy Hemminghaus
image: 10 x 10, sheet: 14 x 14

Pequot, 1986
woodcut
Japanese Etching paper
edition of 15
printed by Anthony Kirk, George Bartko,
 and Marie Arcand
image: 31 x 20, sheet: 35 x 24
Courtesy Vinalhaven Press

Monotypes, 1987
printed from woodblocks by Randy Hemminghaus
image and sheet: 25 x 38 $^{1}/_{2}$
Ishmael I, Mino paper
Ishmael II, Rives BFK paper
Ishmael III, Shoji paper
Kata in Head, Mino paper
Aladdin, Mino paper
Basin Forge, Mino paper
Frankie Lee, Mino paper
Loomings, Mino paper
Basin, Arches Cover paper
Kata In, Mino paper

Spruce, 1987
woodcut
Mino paper
edition of 14; 8 green, 4 blue, 2 lavender
printed by Randy Hemminghaus
image: 48 $^{1}/_{2}$ x 32, sheet: 48 $^{1}/_{2}$ x 32 $^{1}/_{2}$

Tom Tom, 1987
woodcut
Mino paper
edition of 8
printed by Randy Hemminghaus
image: 48 x 32, sheet: 48 $^{1}/_{2}$ x 32 $^{1}/_{2}$

Black Pearl I, 1988
drypoint and monotype
Arches Cover paper
edition of 5
printed by Randy Hemminghaus and Susan Hover
image: 26 $^{1}/_{2}$ x 35 $^{1}/_{2}$, sheet: 29 $^{1}/_{2}$ x 41 $^{3}/_{4}$

Black Pearl II, 1988
drypoint and color roll
Arches Cover paper
edition of 6
printed by Randy Hemminghaus and Susan Hover
image: 26 $^{1}/_{2}$ x 35 $^{1}/_{2}$, sheet: 29 $^{1}/_{2}$ x 41 $^{3}/_{4}$
Collection of Bruce Brown

Black Pearl (State II), 1988
drypoint
Arches Cover paper
edition of 10
printed by Randy Hemminghaus and Susan Hover
image: 26 $^{1}/_{2}$ x 35 $^{1}/_{2}$, sheet: 29 $^{1}/_{2}$ x 41 $^{3}/_{4}$

Keeper I, 1988
drypoint and monotype
Arches Cover paper
edition of 2
printed by Randy Hemminghaus and Susan Hover
image: 26 $^{1}/_{2}$ x 35 $^{1}/_{2}$, sheet: 29 $^{1}/_{2}$ x 41 $^{3}/_{4}$

Keeper II, 1988
drypoint and color roll
Arches Cover paper
edition of 4
printed by Randy Hemminghaus and Susan Hover
image: 26 $^{1}/_{2}$ x 35 $^{1}/_{2}$, sheet: 29 $^{1}/_{2}$ x 41 $^{3}/_{4}$

Keeper (State II), 1988
drypoint
Arches Cover paper
edition of 10
printed by Randy Hemminghaus and Susan Hover
image: 26 $^{1}/_{2}$ x 35 $^{1}/_{2}$, sheet: 29 $^{1}/_{2}$ x 41 $^{3}/_{4}$

Memorial II, 1989
woodcut
Shoji paper
edition of 20
printed by Randy Hemminghaus and Paul Stilpass
image: 10 x 10, sheet: 14 x 14

Night Hawk, 1990
woodcut
Shoji paper
edition of 30
printed by Randy Hemminghaus
image: 34 x 46, sheet: 37 x 49

Acadian Spring, 1991
woodcut
Shoji paper
edition of 30
printed by Randy Hemminghaus
image: 34 x 46, sheet: 37 x 49

German Music, 1991
woodcut
Aqaba paper
edition of 4
printed by Randy Hemminghaus
image and sheet: 72 $^{1}/_{2}$ x 48
Bowdoin College Museum of Art, Brunswick, ME.
 Anonymous gift and Lloyd O. and Marjorie
 Strong Coulter Fund

The Heartland, 1993
engraving, drypoint, and scraping
Rives BFK paper
edition of 6 triptychs, and 6 of each panel
printed by Randy Hemminghaus
image: 36 x 24 (each), sheet: 37 x 24
Courtesy Vinalhaven Press

Jonathan Imber

Carpenter, 1985
lithograph
Arches Cover paper
edition of 28
printed by John C. Erickson and Michelle French
image: 25 x 20 $^1/_2$, sheet: 28 $^3/_8$ x 22 $^1/_2$

The Missing Arm of Venus, 1985
hard-ground etching and aquatint
Arches Cover paper
edition of 12
printed by Kathleen Caraccio
image and sheet: 22 $^3/_8$ x 29 $^3/_8$

Rescue, 1985
aquatint
Arches Cover paper
edition of 20
printed by Kathleen Caraccio
image: 17 $^3/_4$ x 23 $^7/_8$, sheet: 22 x 30

Robert Indiana

American Dream, 1986
hard- and soft-ground etching, aquatint,
 drypoint, and stencil
Arches Cover paper
edition of 10
printed by Anthony Kirk
image: 26 x 12, sheet: 29 $^{15}/_{16}$ x 22 $^3/_8$
Portland Museum of Art, Maine. Museum Purchase,
 1986.238
Trial proofs courtesy Vinalhaven Press

Mother of Exiles, 1986
hard-ground etching and aquatint
Arches Cover paper
edition of 41; 15 in blue, 15 in black, 6 in sepia,
 and 5 in blue with hand-colored letters
printed by Anthony Kirk, Orlando Condeso,
 and Susan Volker
image: 36 x 24, sheet: 47 $^1/_2$ x 31 $^1/_2$
Courtesy Vinalhaven Press
Preparatory drawings courtesy of the artist

For Friendship, 1990
lithograph and embossing
Rives BFK paper
edition of 35
printed by John C. Erickson and Herbert C. Fox
image: 30 x 22 $^1/_2$, sheet: 40 x 29 $^1/_2$

Wall Series, 1990
lithograph
Rives BFK paper
Wall: Two Stone
 edition of 46 in four color variations
Wall: Four Stone
 edition of 12 in two color variations
Wall: Eight Stone
 edition of 12 in two color variations
printed by John C. Erikson and Herbert C. Fox
sheet: 30 x 38 $^1/_4$, image: 15 x 19
Courtesy Vinalhaven Press

First Love, 1991
aquatint
Rives BFK paper
edition of 66
printed by James Davies Cambronne
image: 12 x 11, sheet: 27 x 20
co-published by Vinalhaven Press
 and Todd Brassner

Yvonne Jacquette

Wind/Clouds/Mid-Atlantic States I, 1990
pastel and ink monotype
Rives BFK paper
printed by John C. Erickson
image: 20 x 18, sheet: 30 x 22

Wind/Clouds/Mid-Atlantic States II, 1990
pastel and ink monotype
Rives BFK paper
printed by John C. Erickson
image: 22 $^1/_4$ x 30, sheet: 30 x 22

Wing/Lakeshore I, 1990
pastel and ink monotype
Rives BFK paper
printed by John C. Erickson
image: 20 x 18, sheet: 30 x 22

Wing/Lakeshore II, 1990
pastel and ink monotype
Rives BFK paper
printed by John C. Erickson
image: 20 x 18, sheet: 30 x 22

Vinalhaven Shelves and Ledges, 1991
pastel and ink monotype
Rives BFK paper
variant edition of 9 (A-I)
printed by John C. Erickson
image: 16 $^3/_8$ x 20 $^3/_8$, sheet: 22 $^1/_4$ x 26 $^1/_4$

Dennis Kardon

Critical Mass, 1987
spit-bite aquatint
Belgique Handmade paper
edition of 20
printed by Orlando Condeso, Susan Volker,
 and Chris Clark
image: 15 $^7/_8$ x 20 $^3/_4$, sheet: 23 $^3/_4$ x 29

The Lobsterman's Daughter, 1987
spit-bite aquatint
Belgique Handmade paper
edition of 18
printed by Orlando Condeso, Susan Volker,
 and Chris Clark
image and sheet: 24 $^1/_4$ x 23 $^3/_4$

Komar & Melamid

Peace I: Life of Tolstoy, 1986
series of four diptychs
lithograph, photo-lithograph, and chine collé
Rives BFK paper
edition of 12
printed by Julio Juristo, Barbara McGill Balfour,
 and Randy Hemminghaus
image and sheet: 36 x 24 (each)
Bowdoin College Museum of Art, Brunswick, ME.
 Anonymous gift and Lloyd O. and Marjorie
 Strong Coulter Fund

The Double Revelation, 1990
photolithograph and monotype
Arches Cover paper
variant edition of 30
printed by John C. Erickson
 and Barbara McGill Balfour
image: 24 x 64, sheet: 31 x 72

Apple I, *Apple II*, *Apples I*, *Apples II*, *Apples III*,
Apples IV, *Apples V*, *Beast I*, *Beast II*, *Bouquet I*,
Bouquet II, *Bouquet III*, *Bouquet IV*, *Candles I*,
Candles II, *Car I*, *Car II*, *Car III*, *Car IV*, *Hand I*,
Hand II, *House I*, *House II*, *House III*, *House IV*,
Landscape I, *Landscape II*, *Landscape III*, *Still Life*

Hot Heavy Sears, 1990
woodcut
Aqaba paper
total edition of 83
Praline Mahogany: 27; 3 "SEARS," 1 "IS," 2 "OH,"
 2 "DARK," 2 "HEAVY," 3 "HOT," 14 blank
Wild Pecan: 20; 2 "SEARS," 2 "IS," 2 "OH,"
 2 "DARK," 2 "HEAVY," 2 "HOT," 8 blank
Blond Oak: 15; 1 "SEARS," 1 "IS," 1 "OH,"
 1 "DARK," 1 "HEAVY," 1 "HOT," 9 blank
Honey Maple: 21; 1 "SEARS," 2 "IS," 1 "OH,"
 1 "DARK," 1 "HEAVY," 1 "HOT," 14 blank
printed by John C. Erickson and Randy
 Hemminghaus
image: 10 x 48, sheet: 10 $^1/_2$ x 48 $^3/_4$ each
Portland Museum of Art, Maine. Museum Purchase,
 Friends of the Collection, 1994.10a-c
Courtesy Vinalhaven Press
Bowdoin College Museum of Art, Brunswick, ME.
 Anonymous gift and Lloyd O. and Marjorie
 Strong Coulter Fund

Robert Morris

Continuities, 1988
portfolio of five
soft-ground etching and aquatint
Arches Cover paper
edition of 20
printed by Orlando Condeso and Susan Volker
image: 8 $^5/_8$ x 6 $^7/_{16}$, sheet: 20 $^3/_4$ x 14 $^{15}/_{16}$
Portland Museum of Art, Maine. Museum Purchase,
 Friends of the Collection, 1988.52.1

Conundrums, 1989
portfolio of five
soft-ground etching and aquatint
Arches Cover paper
edition of 20
printed by Orlando Condeso and Susan Volker
image: 4 $^7/_8$ x 6 $^1/_4$ (each), sheet: 15 x 20
Courtesy Vinalhaven Press

Untitled (Dream Series, Blue), 1990
etching and aquatint
Rives BFK paper
edition of 30
printed by Orlando Condeso and Susan Volker
image: 18 x 24, sheet: 28 x 36

Alain Paiement

*Grand Amphitheatre—
According to Horizon*, 1989
photo-etching
Rives BFK paper, mounted on rag board
edition of 10
printed by Randy Hemminghaus, Celeste Bard,
 and Jeanne Bard
image: 21 $^1/_4$ (irregular), board: 33 $^1/_2$ x 51 $^1/_2$
Bowdoin College Museum of Art, Brunswick, ME.
 Anonymous gift and Lloyd O. and Marjorie
 Strong Coulter Fund

Kingsley Parker

Co-published by Vinalhaven Press
 and Condeso/Lawler Gallery

Bank Dicks, 1986
hard-ground etching and aquatint
Rives BFK paper
edition of 30
printed by Orlando Condeso
image: 15 $^3/_4$ x 15 $^1/_4$, sheet: 22 $^1/_2$ x 22

Watch Dog 1300 Hours, 1987
hard-ground etching and aquatint
Rives BFK paper
edition of 30
printed by Orlando Condeso
image: 25 x 22, sheet: 31 x 28

Watch Dog 2100 Hours, 1987
hard-ground etching and aquatint
Rives BFK paper
edition of 30
printed by Orlando Condeso
image: 25 x 22, sheet: 31 x 28

Alison Saar

Blue Plate Special, 1993
woodcut and chine collé
Arches Cover paper
edition of 20
printed by Randy Hemminghaus
 and Jonathan Higgins
image: 11 $^{11}/_{16}$ x 11 $^{15}/_{16}$, sheet: 25 $^1/_4$ x 19 $^5/_8$
Portland Museum of Art, Maine. Museum Purchase,
 Friends of the Collection, 1994.11a-c

Blue Plate Special, 1993
etching, lithograph, and chine collé
Arches Cover paper
edition of 20
printed by Randy Hemminghaus
 and Jonathan Higgins
image: 24 $^3/_{16}$ x 24 $^1/_2$, sheet: 29 x 28 $^3/_4$

Heart, 1993
soft-ground etching and chine collé
Arches Cover paper
edition of 20
printed by Randy Hemminghaus
 and Jonathan Higgins
image: 5 $^1/_2$ x 5 $^1/_2$, sheet: 19 $^7/_8$ x 15 $^{13}/_{16}$

Heart and Sole, 1993
hard- and soft-ground etching, aquatint,
 and chine collé
Arches Cover paper
edition of 20
printed by Randy Hemminghaus
 and Jonathan Higgins
image: 15 $^3/_4$ x 7, sheet: 22 $^1/_4$ x 14
Portland Museum of Art, Maine. Museum Purchase,
 Friends of the Collection, 1994.14

Man Club, 1993
soft-ground etching, lithograph, and woodcut
Rives BFK and Aqaba paper
edition of 20
printed by Randy Hemminghaus
 and Jonathan Higgins
Rives: 23 x 44 $^1/_2$
Aqaba: 18 $^1/_2$ x 40
Portland Museum of Art, Maine. Museum Purchase,
 Friends of the Collection, 1994.12a,b

Monotypes, 1994
Rives BFK paper
printed by Jonathan Higgins and Chris Clark

Tobacco Demon
variant edition of 2
image and sheet: 28 x 21 $^3/_4$
Courtesy Vinalhaven Press

Pile O' Crow
unique
sheet: 44 $^5/_8$ x 29 $^{15}/_{16}$, image: 19 $^3/_4$ x 27 (irregular)
Courtesy Vinalhaven Press

Dig
unique
image and sheet: 44 $^3/_4$ x 30

Rose Tattoo
variant edition of 3
image and sheet: 29 $^{15}/_{16}$ x 44 $^7/_{16}$

Cotton Demon
variant edition of 2
image and sheet: 44 $^9/_{16}$ x 30

Snake Man, 1994
woodcut and lithograph
Okawara paper
edition of 20
printed by Jonathan Higgins, Kathleen Beckert,
 and Scott Smith
image and sheet: 27 $^3/_4$ x 37 $^1/_{16}$
Collection of Bruce Brown
Trial proof courtesy Vinalhaven Press

Tattoo, 1994
soft-ground etching and aquatint
Rives BFK paper
edition of 20
printed by Jonathan Higgins and Karoline Schleh
sheet: 22 x 30

Peter Saul

Monotypes, 1995
Rives BFK paper
image and sheet: 30 x 22 $^1/_2$
printed by Randy Hemminghaus

Superwoman #1
variable edition of 2

Superwoman #2
variable edition of 2
Courtesy Vinalhaven Press

Bizzaro Superwoman
variable edition of 2
Courtesy Vinalhaven Press

Goddess, 1995
photo-etching
Rives BFK paper
edition of 15
printed by Randy Hemminghaus
image: 21 $^3/_4$ x 14 $^1/_2$, sheet: 30 x 22 $^1/_4$
Courtesy Vinalhaven Press

I'm Splitting, 1995
photo-etching
Rives BFK paper
edition of 10
printed by Jonathan Higgins
image: 7 $^3/_8$ x 8, sheet: 22 x 15
Courtesy Vinalhaven Press

Mona Lisa Throw Up, 1995
photo-etching
Rives BFK paper
edition of 10
printed by Jonathan Higgins
image: 7 $^3/_4$ x 7 $^1/_4$, sheet: 22 x 15
Courtesy Vinalhaven Press

Soft Watch on a Toilet, 1995
photo-etching
Rives BFK paper
edition of 10
printed by Jonathan Higgins
image: 7 $^1/_4$ x 7 $^7/_8$, sheet: 22 x 15

Joan Thorne

Co-published by Vinalhaven Press and Graham
Modern Gallery, New York

Absalo, 1985
hard-ground etching and aquatint
 printed à la poupée
Rives BFK paper
edition of 25
printed by Maurice Payne
image: 29 $^1/_2$ x 21 $^3/_4$, sheet: 36 $^1/_4$ x 29 $^1/_2$

Fata Morgana, 1985
lithograph
Rives BFK paper
edition of 31
printed by Lynne Allen, John C. Erickson,
 and Michelle French
image and sheet: 23 $^1/_8$ x 30 $^1/_4$

Robert Zakanitch

Jamboree Crows, 1986
diptych
lithograph
Rives BFK paper
edition of 31
printed by Julio Juristo, Barbara McGill Balfour,
 Alan Flint, and Randy Hemminghaus
image and sheet: 24 $^1/_4$ x 18 $^1/_8$ (each)

Sunday Crows, 1986
diptych
lithograph
Rives BFK paper
edition of 31
printed by Julio Juristo, Barbara McGill Balfour,
 Alan Flint, and Randy Hemminghaus
image and sheet: 24 $^1/_{16}$ x 19 $^1/_{16}$ (each)

Glossary of printmaking terms

A la poupée:
(French) Term used for applying inks selectively to a plate so that a multi-color image can be made from one impression.

Aquatint:
An etching technique that creates areas of tone. A plate is treated with a fine layer of rosin prior to submersion in an acid bath. The acid bites the plate between the grains of rosin, creating a rich texture whose darkness is determined by the length of exposure to the acid.

Artist's proof (A.P.):
Proofs printed for the artist and excluded from the numbered edition.

Bon à tier (B.A.T.):
(French, "good to pull") The proof approved by the artist as the standard of printing for the edition.

Chine collé:
(French, "Chinese paste") A process used to adhere a thin paper of a different color or texture onto a larger, heavier sheet during printing.

Drypoint:
An intaglio process in which a plate is directly incised with a needle. The result, when printed, is a raised cut or burr that produces a velvety line. Editions are usually small because the burr breaks down after consecutive printings.

Edition:
The total number of prints (exclusive of proofs) of a single image or series of images printed from the same plate or stone.

Engraving:
An intaglio technique in which a burin is used to cut into a plate, creating deep or tapered lines depending on the pressure used. Engraving differs from etching in that no acid is used and differs from drypoint because the metal is dug out and burrs are scraped off the plate.

Etching:
An intaglio process in which a metal plate is coated with an acid-resistant ground and drawn upon with etching tools to expose the metal. The plate is then immersed in an acid bath that eats away or "bites" the exposed areas, causing depressions that can be inked and printed.

Hard-ground etching:

An etching process in which an acid-resistant compound is heated until it becomes liquid and is then applied to a warmed metal plate. When the plate has air-cooled and the ground re-hardens, it is ready to be drawn upon with etching tools.

Intaglio:

Techniques that involve scratching or etching line or tonal areas into the surface of a metal plate. The plate is covered with ink and then the top surface is wiped clean, leaving ink in the line or tonal areas. Wet paper is placed on the plate and run through a press. The paper is forced into the crevices containing the ink, and the image is transferred to the paper.

Linoleum cut (Linocut):

A relief print that is carved into linoleum.

Lithography:

A grease-based drawing is applied to a stone or aluminum plate and treated chemically. The stone is kept wet and rolled with ink. Only the grease drawing attracts the ink; the water on the rest of the stone or plate repels the ink. When the stone is fully charged with ink, it is run through a high-pressure press, which transfers the image to a sheet of paper.

Monotype:

An image is drawn or painted onto an unworked plate (metal, glass, or plexi-glass) and pressed onto paper to create, a unique print. A second impression can sometimes be pulled from the plate, producing a "ghost" image.

Photo-etching:

A technique by which an image is produced on an etching plate by photographic means.

Photo-lithograph:

A technique by which an image is produced on a lithographic plate through photographic means.

Printer's proof (P.P.):

Proofs printed specially for the printers who work on an edition.

Relief:

Any print in which the image is printed from the raised surface of a block. Woodcut, linocut, and relief etching are examples.

Scraping:

A method for making changes on an intaglio plate by scraping below the incised lines with a wedge-shaped tool until the scraped area can no longer hold ink. The surface is often smoothed and polished with a burnisher.

Soft-ground etching:

An etching technique in which paper is laid over a non-drying ground and drawn upon. The soft-ground adheres to the paper, exposing the metal, which can then be bitten in an acid bath. The quality of line is often soft and grainy and can reveal the texture of the paper used in the drawing.

Spit-bite:

A variation of aquatint in which the artist paints an acid solution on the prepared plate rather than immersing the plate in an acid bath.

Stencil:

A masking material such as paper, plastic, or fabric is cut to allow ink or paint to pass through and print on another surface.

Trial proof (T.P.):

Any test impression taken from a plate, block, stencil, or other print matrix to test how that particular image, or part of an image, will reproduce.

Variable edition:

An edition of prints that use the same printing matrices (plates, blocks, screens, stones, etc.) but shows different variations of inking, use of papers, arrangements of printing elements, etc. It may also refer to a group of monoprints that are developed as a series or variation on a theme.

Vinalhaven archive proof (V.P.):

Proof printed for the archive, which includes an impression of every print editioned by the press.

Woodcut:

A form of relief printing in which a piece of wood (usually the plank side of soft wood) is carved so that the raised areas carry ink to produce the design.

Working proof (W.P.):

A proof taken during the development of an image on which notations and corrections concerning color changes, plate changes, pressure of the press, etc., are made by the artist or the printer.